POSTCARD HISTORY SERIES

Along the Wissahickon Creek

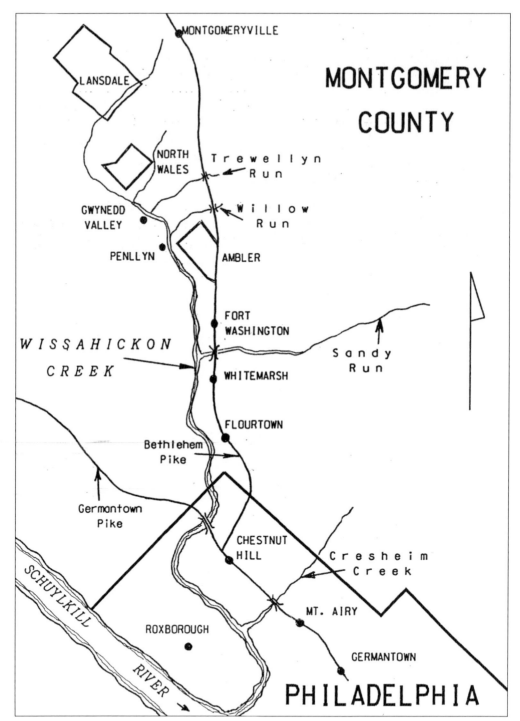

THE WISSAHICKON CREEK. This map shows Wissahickon Creek from its beginning near Montgomeryville, in Montgomery County, to its emptying into the Schuylkill River, in Philadelphia. Nearby towns and boroughs are also shown. Several known tributaries such as Cresheim Creek, Sandy Run, and others are also indicated.

POSTCARD HISTORY SERIES

Along the Wissahickon Creek

Andrew Mark Herman

ARCADIA

Published by Arcadia Publishing,
Charleston SC, Chicago IL, Portsmouth NH, San Francisco CA

Printed in Great Britain

Library of Congress Catalog Card Number: 2003116601

For all general information, contact Arcadia Publishing:
Telephone 843-853-2070
Fax 843-853-0044
E-mail sales@arcadiapublishing.com
For customer service and orders:
Toll-free 1-888-313-2665

Visit us on the Internet at www.arcadiapublishing.com

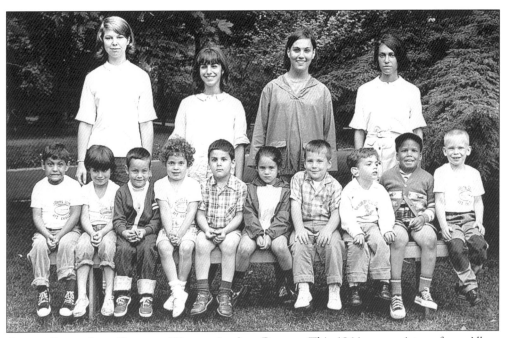

ALLENS LANE ART CENTER, WHERE IT ALL BEGAN. This 1964 camp picture from Allens Lane Art Center shows the author (third from left), who grew up in nearby Mount Airy. This camp had summer programs focusing on arts and sports activities. Located at Allens Lane and McCallum Street, the camp is part of Fairmount Park and adjoins the Cresheim Creek section of the park. As a youngster, the author loved walks and hikes into the park to the Wissahickon Creek. The joyous feelings of hiking through the woods and rocks along the creek remain a permanent memory. As with many others who have enjoyed the Wissahickon, this unique place remains a special part of the author's life.

CONTENTS

ACKNOWLEDGMENTS

It is with much gratitude that I offer my thanks to the following individuals who offered guidance and assistance with the book: my wife, Claudia, who spent many hours helping with the book preparation; my parents, Marvin and Paula Herman, for preserving family pictures from my early Wissahickon days; and friend and bookseller Hugh Gilmore of Chestnut Hill for helping with historical data pertaining to the Wissahickon. I extend very special thanks to the following individuals who offered their time and expertise about the Wissahickon Creek: Tom Pelikan, executive director of the Friends of the Wissahickon; David Froehlich, executive director of the Wissahickon Valley Watershed Association; and Bob Gutowski, director of public programs at the Morris Arboretum.

For more information regarding the preservation and history of the land along the Wissahickon, please visit the following Web sites: the Friends of the Wissahickon, at www.fow.org; the Wissahickon Valley Watershed Association, at www.wvwa.org; and the Morris Arboretum, at www.morrisarboretum.org.

To my children, Lauren, Ali, and Maddie,
future keepers of the Wissahickon.

INTRODUCTION

Beginning with a series of underground springs in central Montgomery County, the Wissahickon Creek flows for 21 miles before emptying into the Schuylkill River, below Manayunk in Philadelphia. Within those 21 miles, the creek passes through a gently rolling landscape of hills and valleys in Montgomery County. Then, almost magically, as the creek enters Philadelphia, a wild, steep, rocky wooded gorge emerges. Hills and cliffs rise several hundred feet above the creek's water. The scenic beauty of the constant flowing stream has attracted individuals to its banks for hundreds of years. An early account states that in 1694, an elusive group of religious followers left the confines of Germantown to settle near the creek and built a wooden tabernacle. Attracted by the beauty of the creek valley, the group along with their leader, Johannes Kelpius, practiced mysticism and meditation and lived in caves. They were often referred to as the Hermits of the Wissahickon.

The Native Americans of the Lenni Lenape tribe named the creek *Wisauksicken,* meaning "yellow-colored stream." Another name, *Wisamickon,* has been interpreted to mean "catfish creek." As time progressed, European settlers corrupted the word into *Wissahickon.*

With the arrival of William Penn and his followers, Germans established a community near the Wissahickon called Germantown. Anxious to prosper and work, they brought with them skills and abilities to harness the waters of the creek. In 1690, German-born William Rittenhouse erected a paper mill on Monoshone Run near the Wissahickon. During this early time, Welsh immigrant Edward Farmar constructed a mill along the Wissahickon in Wide Marsh, known today as Whitemarsh. The 1700s saw a rapid growth of mills along the Wissahickon. There are many to mention, but the most prominent were Foulke's Mill, near Penllyn; Abraham Evans Mill, above Gwynedd; the Streeper and Cleaver Mills of Springfield; and the Livezey, Magarge, and Robeson Mills of Philadelphia. The clatter of waterwheels up and down the Wissahickon broke the peaceful silence that the Native Americans had known for centuries. Change filled the air in the Wissahickon Valley.

Prosperous villages rapidly developed near Wissahickon Creek. Chestnut Hill, Flourtown, Fort Washington, and Penllyn all owe their existence and location to the Wissahickon. However, the American Revolution interrupted the peaceful settlements of Penn's colony, as the battle for independence played out.

The well-documented Battle of Germantown, which George Washington's army lost to the British in October 1777, signaled much activity in the Wissahickon Valley. Although no other major battles were fought there, the area was literally crisscrossed with American and British

armies attempting to gain control over Philadelphia and the war. In November 1777, Washington's troops headed for Whitemarsh, opting to set up forts and encampments rather than attack the British. Three of the largest hills overlooking the Wissahickon Valley provided great defensive positions where the Americans would not only be able to keep a healthy watch on the activities of the British but could also avoid being attacked. The encampments known as Militia Hill, Fort Hill, and Camp Hill led to the creation of Fort Washington State Park, preserving some historic ground.

Farther south along the Wissahickon, efforts were made to preserve a large portion of the creek valley. During the mid-1800s, manufacturing in Philadelphia was rapidly expanding and pollution was on the rise. Philadelphia was anxious to preserve its drinking water, and after preserving land along the Schuylkill River, the city acquired in 1868 the Wissahickon Valley Corridor, which comprised more than 1,800 acres.

Much of the land along the Wissahickon Creek was preserved through land acquisitions by Fairmount Park, Fort Washington State Park, and in 1932, the Morris Arboretum in Chestnut Hill. However, even with these successes, parts of the valley were being threatened with destruction.

In the last several decades, rapid suburban expansion has threatened the landscape of the upper portions of the Wissahickon Valley. Land that has been farmed for generations is rapidly being lost to development. In 1957, the Wissahickon Valley Watershed Association was organized to help preserve and protect the upper sections of the creek valley. In Philadelphia, as funding for Fairmount Park has decreased, the Friends of the Wissahickon have been sponsoring park cleanups, trail restorations, and tree plantings. From the efforts of these civic-minded environmental groups, the Wissahickon Green Ribbon Preserve was created. Green ribbons are defined as long jointed connections of open space, usually found along a waterway.

Preservation of the Wissahickon Creek is also found within another context—the wide assortment of old postcard views that show us today what the valley was like 100 years ago. Without some of these antique images, important mills, bridges, and farms might have remained undocumented. Judging by the vast quantities of postcards produced and used, the Wissahickon must have been a favorite scene to send a friend or family member. It is the wonderful history and beauty of the Wissahickon that has attracted many postcard publishers to produce images of the creek and its surroundings.

Several local postcard publishers produced images of the Wissahickon. These include William H. Sliker, of Bridesburg; W. W. Miller, of North Wales; and John Bartholomew, of Lansdale. Germantown's own Philip Moore, who had a studio at 6646 Germantown Avenue, produced beautiful color views. Larger, nationally known companies such as the Rotograph Company from New York, the World Postcard Company from Philadelphia, and the Detroit Publishing Company produced numerous images of the creek. These postcard publishers, along with others, are represented in this book, and their images are identified when possible.

In 1832, it was the internationally known actress and writer Fanny Kemble who first wrote on the beauty of the Wissahickon. Edgar Allen Poe, who frequently visited the Wissahickon, wrote a poem about the creek in 1844. Kemble and Poe, along with a host of many writers and artists, helped establish the Wissahickon as a well-known natural landmark. Further recognition of the Wissahickon Valley came in 1964, when it was designated a National Natural Landmark by the Department of the Interior.

This book will allow the reader to journey down the entire length of the Wissahickon Creek, from beginning to end. It is the first book to fully illustrate the Wissahickon Creek in its entirety. Using old postcards from my own collection, I hope to present a visually pleasing and informative guide to this beautiful and historic stream.

—Andrew Mark Herman
January 20, 2004

One

THE WISSAHICKON'S
ORIGIN

THE WISSAHICKON CREEK'S ORIGIN. The Wissahickon Creek has several origins and two distinct branches. The main branch of the creek begins in Montgomery Township, north of Knapp Road in a protected wooded area known as Knapp Park. This branch flows southeasterly through the eastern portion of Lansdale Borough and then turns south and joins with a second branch. This second branch begins near Sumneytown Pike and flows below North Wales Borough, where the two branches join to become one stream. At this point, the creek flows south toward Gwynedd Valley in an area that is composed of gently sloping hills.

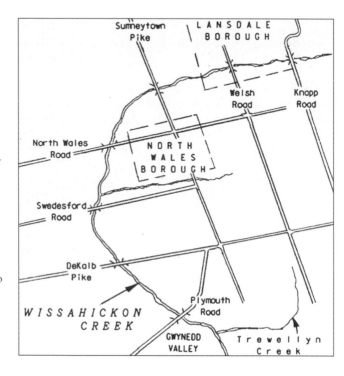

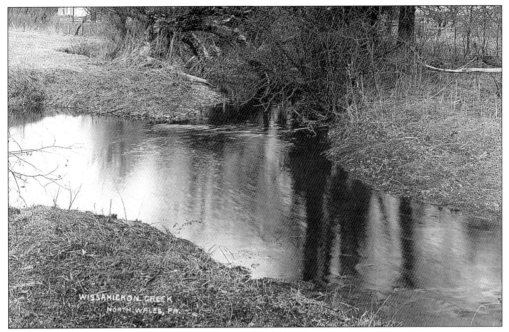

THE WISSAHICKON CREEK, NORTH WALES. This 1910 view of the Wissahickon near North Wales illustrates the stream's humble beginnings. Here, the creek is no wider than a small brook and is most likely not far from its spring-fed source. (Miller postcard.)

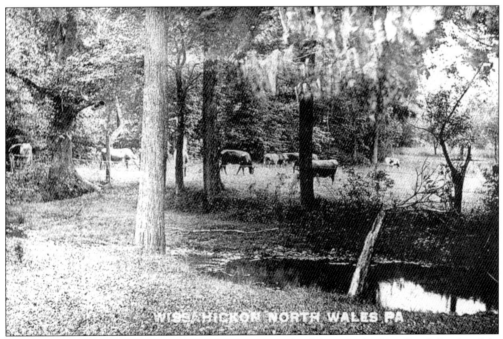

THE WISSAHICKON CREEK, NORTH WALES. A branch of the Wissahickon Creek has it origin near North Wales Borough, north of Sumneytown Pike and east of Prospect Street. This postcard shows farm animals grazing near the creek, possibly very close to a series of underground springs that make up its origin. (Bartholomew postcard.)

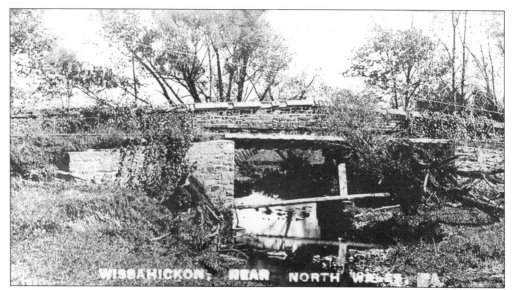

THE WISSAHICKON CREEK, NEAR NORTH WALES. Hidden beneath the wood planking in this 1907 view is a picturesque stone arch bridge rising over a narrow Wissahickon Creek. Montgomery County built many of these bridges over waterways throughout the 1800s. While some survive today, many have been replaced. This bridge, located in the once rural area of North Wales, is probably no longer standing. The wooden planks shown were installed by farmers in an effort to keep their cattle roaming away from their pastures. (Bartholomew postcard.)

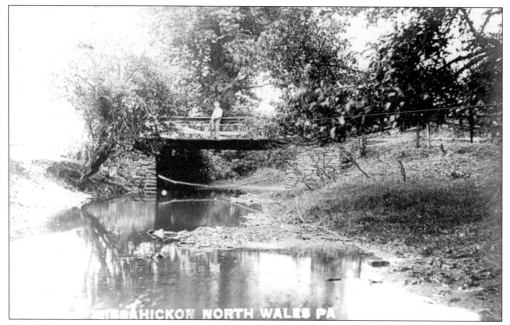

THE WISSAHICKON CREEK, NEAR NORTH WALES. A young man pauses to observe the beauty of the Wissahickon Creek from an old rustic bridge near North Wales Borough. Amid the beautiful Montgomery County countryside, the Wissahickon provides very scenic views. (Bartholomew postcard.)

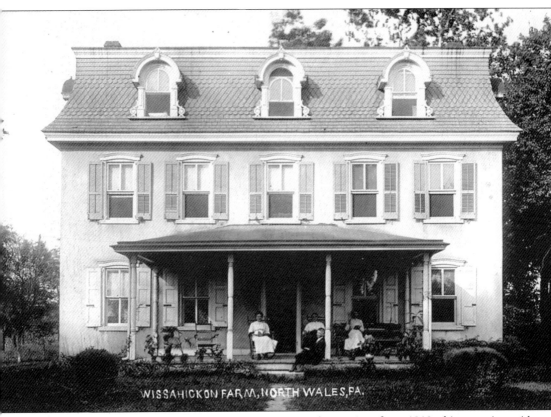

THE WISSAHICKON FARM, NORTH WALES. Pictured in a view from 1910, this attractive mid-1800s house stood along the Wissahickon Creek near Sumneytown Pike and Dickerson Road, north of North Wales in Upper Gwynedd Township. Called the Wissahickon Farm, the property also included a large barn. Currently, no buildings stand on this once thriving farm. (Miller postcard.)

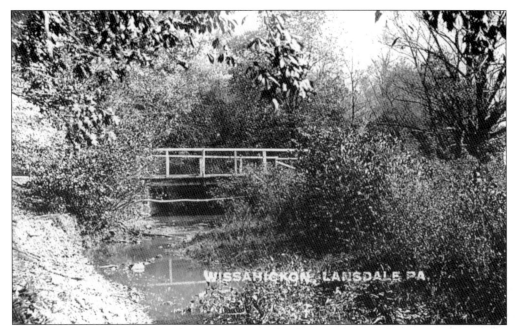

THE WISSAHICKON CREEK, LANSDALE. Not far from its beginning, a relatively narrow Wissahickon Creek is shown here in 1910 near Lansdale Borough, Montgomery County. The creek flows near the present-day eastern boundary of the town. This rural scene, photographed by John Bartholomew, is characteristic of the landscape near the creek at the time.

THE WISSAHICKON CREEK, NEAR LANSDALE. In this 1907 view, mature woodland trees rise above sunlit reflections of the Wissahickon Creek in Upper Gwynedd Township, near Lansdale. (Bartholomew postcard.)

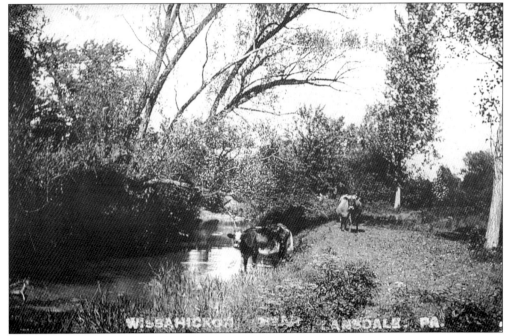

THE WISSAHICKON CREEK, NEAR LANSDALE. Lansdale photographer John Bartholomew captured this simple country scene of cows wandering along the Wissahickon in 1907. The rural landscape that once dominated Montgomery County is reflected in many postcard views of the Wissahickon Valley.

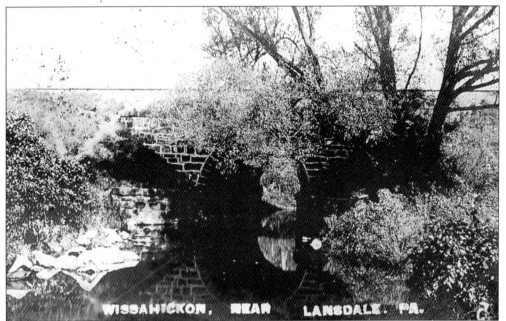

THE WISSAHICKON CREEK, NEAR LANSDALE. Beautiful reflections of a quaint stone arch bridge are seen in the Wissahickon Creek near Lansdale in this 1907 view. The bridge shown here most likely carried the old North Pennsylvania Railroad, later the Reading Railroad, over the Wissahickon. (Bartholomew postcard.)

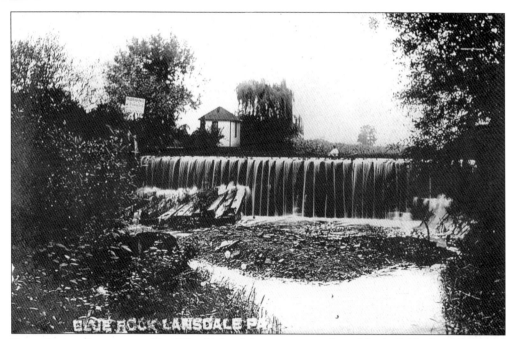

BLUE ROCK, LANSDALE. The Wissahickon's beauty attracted wealthy individuals who erected lavish estates near the creek and took full advantage of its splendid scenery. The successful Lansdale oil merchant Theodore Weidman (1861–1917) dammed the creek to build a mansion, a lake, and a waterfall. Besides its scenic quality, the creek provided an assortment of outdoor activities, including boating, fishing, and swimming. (Bartholomew postcard.)

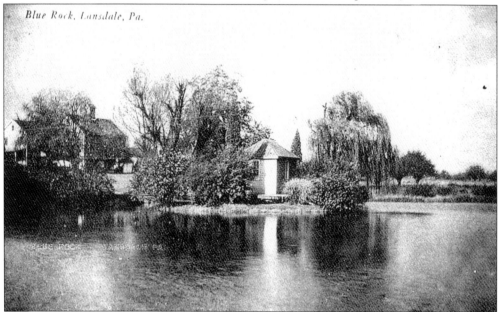

BLUE ROCK, LANSDALE. This 1920 view shows the expanse of the lake on the Blue Rock estate. Perhaps bluish rocks near the creek gave the estate its name, but there is no mention of this. The splendid mansion, outbuildings, lake, and waterfalls no longer exist, though some of the ground along the creek is preserved in Wissahickon Park, in the borough of Lansdale.

15

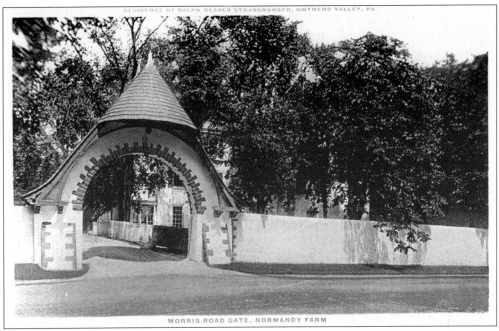

MORRIS ROAD GATE, NORMANDY FARM

NORMANDY FARM. One of the most unique farm complexes in the Wissahickon Valley is Normandy Farm, in Whitpain Township at Morris Road and Dekalb Pike. In 1912, Ralph Beaver Strassburger purchased the old farm and later built the locally famous stuccoed white walls and arched entrances. Strassburger would eventually own the *Norristown Times Herald*. Shown in this view is a farm entrance on Morris Road *c.* 1920. (Detroit Company postcard.)

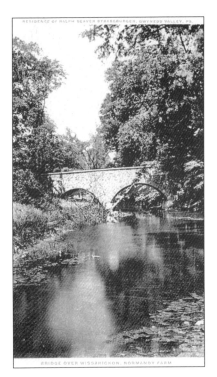

BRIDGE OVER WISSAHICKON, NORMANDY FARM

BRIDGE OVER THE WISSAHICKON CREEK, NORMANDY FARM. Strassburger increased the size of his farm by acquiring neighboring land in Lower Gwynedd Township. Eventually, his 1,500-acre farm was the largest in Montgomery County. This view, dating from 1915, shows the Swedesford Road bridge, built over the Wissahickon Creek in 1873 on land adjoining Strassburger's farm. This bridge is still standing and is part of the historic Evans–Mumbower Mill complex. The entire Normandy Farm land has been developed for use as residential and commercial property, with much of the original buildings remaining. (Detroit Publishing Company postcard.)

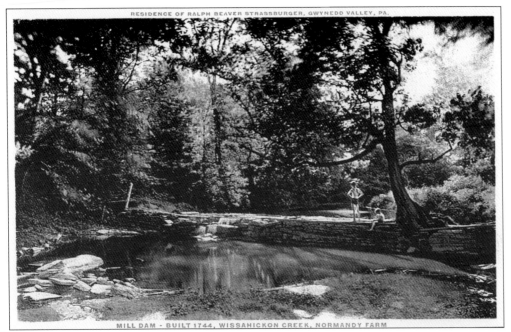

MILL DAM - BUILT 1744, WISSAHICKON CREEK, NORMANDY FARM

THE MILLDAM, WISSAHICKON CREEK, NORMANDY FARM. According to this 1915 postcard, pictured above is the 1744 milldam on the Wissahickon at Normandy Farm. This would have been an early remnant of the 1745 Abraham Evans Mill, now the site of the 1835 Evans-Mumbower Mill, located on Swedesford Road. Two young boys are shown standing on the dam, perhaps ready for a dip in the refreshing Wissahickon waters. (Detroit Publishing Company postcard.)

WISSAHICKON CREEK, NORMANDY FARM

THE WISSAHICKON CREEK, NORMANDY FARM, GWYNEDD VALLEY. Dating from 1915, this view shows the Wissahickon Creek in a wooded area in the vicinity of Normandy Farm. The creek is very shaded by the towering trees. (Detroit Publishing Company postcard.)

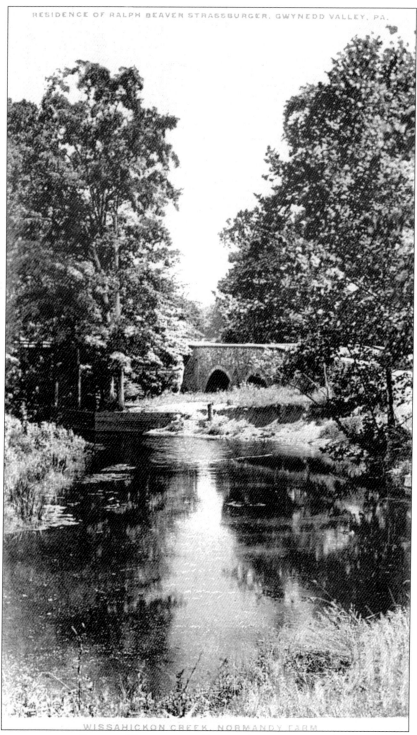

RESIDENCE OF RALPH BEAVER STRASSBURGER, GWYNEDD VALLEY, PA.

WISSAHICKON CREEK, NORMANDY FARM

THE WISSAHICKON CREEK, NORMANDY FARM. A 1915 view shows the shimmering Wissahickon on the grounds of the former Ralph Strassburger estate. The old Swedesford Road Bridge is in the background. (Detroit Publishing Company postcard.)

18

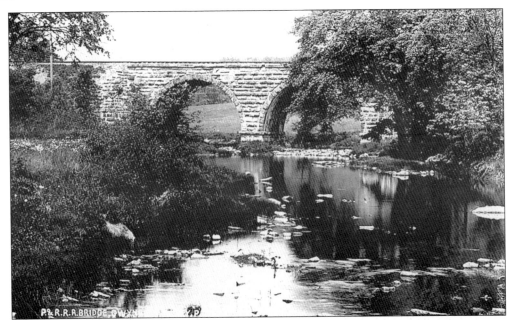

THE PHILADELPHIA AND READING BRIDGE, GWYNEDD VALLEY. In the 1850s, construction began on a new railroad line from Philadelphia to Bethlehem and points north. It was called the North Pennsylvania Railroad and was quickly purchased out by the Reading Railroad. Shown here is the Philadelphia and Reading Railroad bridge over the Wissahickon Creek in Lower Gwynedd Township. Its beautiful stone arches set amid the lovely countryside made this 1910 postcard setting quite ideal. (Miller postcard.)

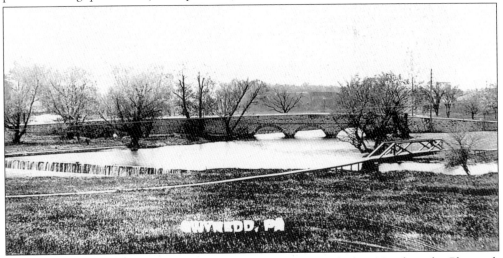

GWYNEDD, PENNSYLVANIA. This 1910 view shows the Wissahickon Creek at the Plymouth Road bridge near Gwynedd, in Lower Gwynedd Township. Plymouth Road is an old Colonial highway that ran between the Quaker settlements of Gwynedd and Plymouth Meeting. The bridge, dating from 1839, has been improved and was slightly altered in 1914 and again in 1977. To the right is a wooden footbridge that spans Trewellyn Creek, a small tributary to the Wissahickon. Trewellyn, or Treweryn, is named after a stream in Wales. It was not uncommon in the 1700s for Europeans arriving in America to name places after those of their native homeland. (Bartholomew postcard.)

E. B. Smith's Ford, Gwynedd Valley. Located off Plymouth Road near Evans Road and the Wissahickon Creek was the drive to Edward B. Smith's residence. This unusual view, dating from 1915, shows Smith's private drive fording the Wissahickon Creek. The ford can still be seen today, although the drive has long been abandoned. (Miller postcard.)

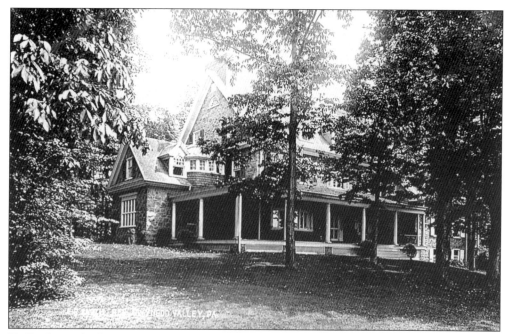

E. B. Smith's Residence, Gwynedd Valley. The Smith residence, dating back to the 1800s, is beautifully situated on a crest of a hill overlooking the Wissahickon Valley. Built of native stone, the house still stands today. This view dates from 1915. (Miller postcard.)

Two

THE WISSAHICKON AT PENLLYN AND AMBLER

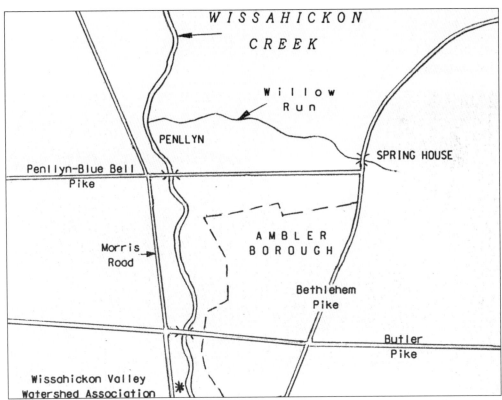

THE WISSAHICKON CREEK AT PENLLYN AND AMBLER. Here, the Wissahickon Creek continues on its southbound course through gently rolling hills as it passes by the town of Penllyn and the borough of Ambler. Notable features in this chapter are Willow Run (a tributary) and the Wissahickon Valley Watershed Association's headquarters on Morris Road.

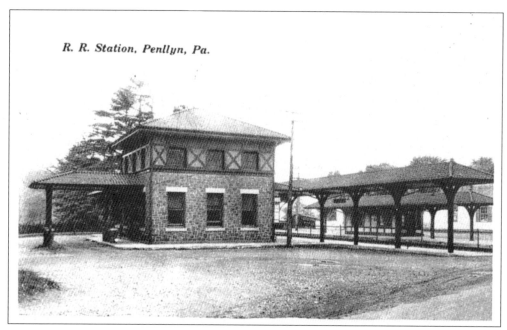

R. R. Station, Penllyn, Pa.

THE RAILROAD STATION, PENLLYN. The village of Penllyn was centered around the North Pennsylvania Railroad station and an old general store. The railroad arrived in the mid-1850s and allowed easy access from this area to Philadelphia. Since the early 1700s, this area was home to many wealthy city families. A large Quaker following, as well as an early African American settlement, made this community near the Wissahickon a diverse area.

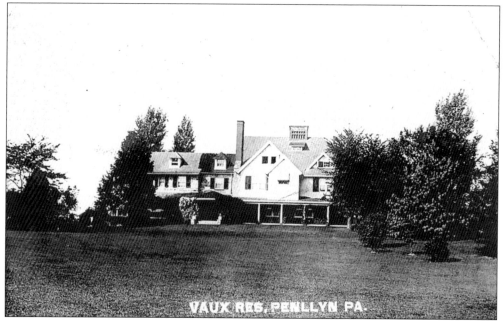

VAUX RES. PENLLYN PA.

THE VAUX RESIDENCE, PENLLYN. An example of the gentrified county life of the Penllyn area is the stately Vaux residence, built in 1883 for the son of Philadelphia mayor Richard Vaux. Seen here in a postcard from 1910, the spacious home and grounds are located along Penllyn-Blue Bell Pike, a quarter-mile from the Wissahickon Creek. (Bartholomew postcard.)

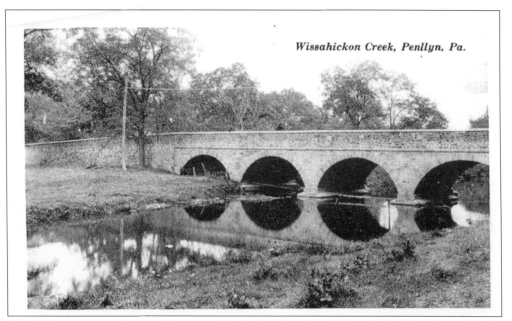

Wissahickon Creek, Penllyn, Pa.

THE WISSAHICKON CREEK, PENLLYN. Dating back to the 1800s, the Penllyn-Blue Bell Pike bridge over the Wissahickon Creek was a beautiful multi-arched stone structure. Unfortunately, this lovely span no longer exists and has been replaced by a modern concrete bridge. However, the old roadway and stone bridge approaches can still be seen in a wooded area north of the newer bridge. With the help of the Wissahickon Valley Watershed Association and the community, this wooded area is now preserved in what is now known as the Penllyn Natural Area.

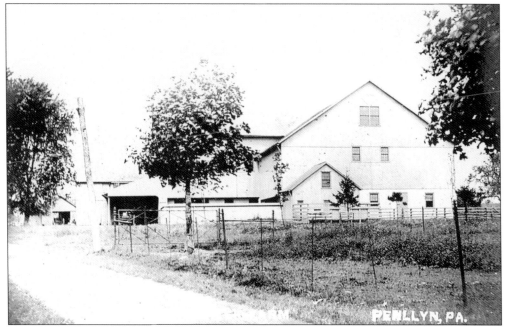

WILLOW CREEK FARM, PENLLYN. Willow Creek Farm was located along Penllyn-Blue Bell Pike near Penllyn. The farm was named after Willow Run, which ran alongside the property. Shown here is a large barn on the farm. (Bartholomew postcard.)

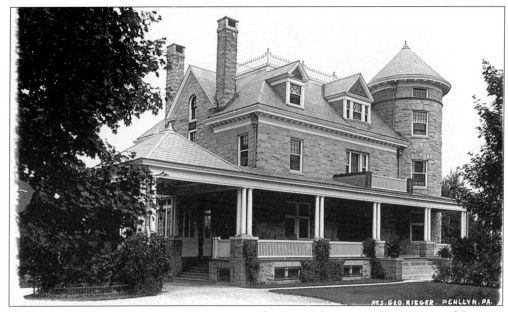

THE GEORGE RIEGER RESIDENCE, PENLLYN. The George Rieger residence is one of the most elegant mansions built in the Penllyn area. The beautiful stone mansion, built in 1899, contains numerous balconies, fireplaces, and an unusual circular three-and-a-half-story tower. Still standing on Penllyn-Blue Bell Pike, the house is now part of a nursing home complex. (Sliker postcard.)

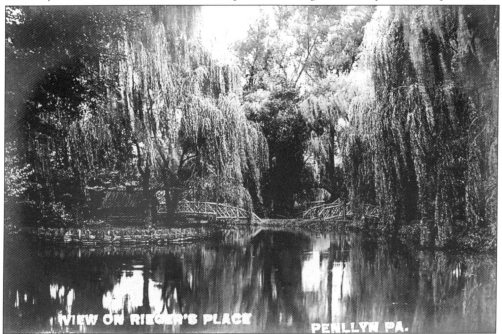

RIEGER PLACE, PENLLYN. Rieger's mansion was ideally situated along Willow Run—a small stream that flows into the Wissahickon near Penllyn Station. Rieger, whose fortune came from brewing beer, embellished Willow Run with numerous wooden bridges, a log house (shown at the left), and beautiful weeping willow trees to create a lovely setting. Willow Run still flows behind the property in a wooded area. (Bartholomew postcard.)

24

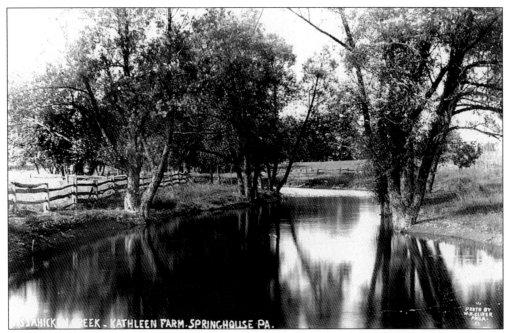

THE WISSAHICKON CREEK, KATHLEEN FARM, SPRING HOUSE. Plenty of open pastures and meadows line the Wissahickon Creek in the Spring House–Penllyn area. Mentioned on this 1915 postcard is the Kathleen Farm, which the author has not been able to find on any atlases or histories of this area. It remains a mystery as to where this exact location was. (Sliker postcard.)

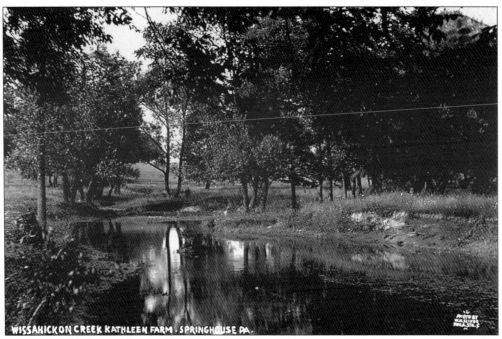

THE WISSAHICKON CREEK, SPRING HOUSE, PENNSYLVANIA. This is a 1915 view of the Wissahickon Creek, near the Spring House–Penllyn area of Lower Gwynedd Township. (Sliker postcard.)

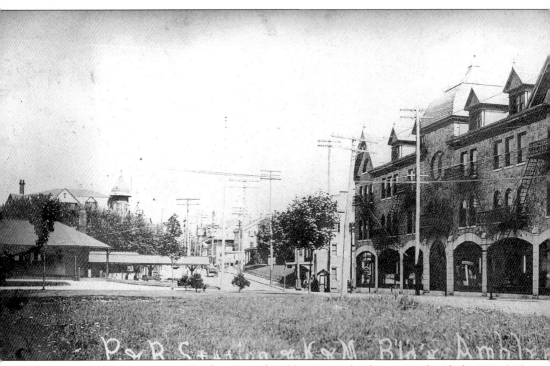

AMBLER, PENNSYLVANIA. The founding of Ambler is very closely associated with the Wissahickon Creek, which lies on the western edge of the borough. Originally, in 1855, when the North Pennsylvania Railroad was built in this still unnamed community, the first train station was called Wissahickon. The borough of Ambler was incorporated in 1888 and developed into a thriving industrial center. This view from 1905 looks east on Butler Pike toward the railroad station, shown to the left. The large structure to the right, built in 1890, was the Opera House, which also housed the town's first library. This building is no longer standing. (Bartholomew postcard.)

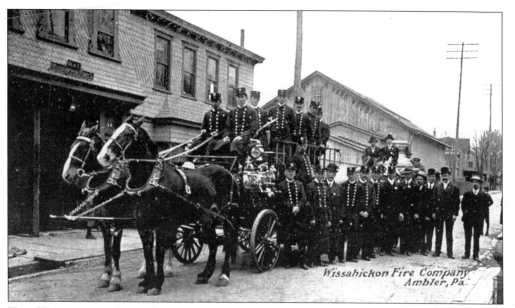

THE WISSAHICKON FIRE COMPANY, AMBLER. The influence the Wissahickon Creek has on our area is quite profound. Its name can be found in many places—from schools to roads and, in this case, a fire company. When Ambler's fire department was organized in 1890, the name chosen was the Wissahickon Fire Company. This scene, posed along Main Street in 1905, shows a horse-drawn fire truck with a fireman from the company. The Wissahickon Fire Company still serves the community today.

NEAR AMBLER. Besides Willow Run and Trewellyn Creek, there are numerous unnamed streams in Montgomery County that flow into the Wissahickon Creek. This view shows a small stream somewhere near Ambler. (Bartholomew postcard.)

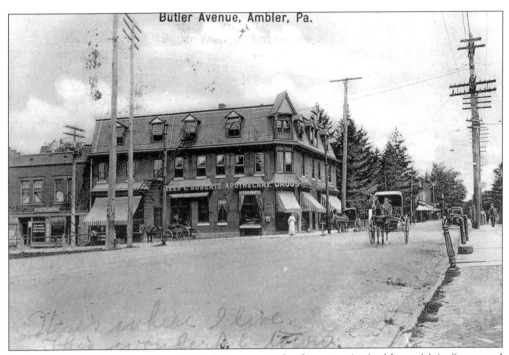

AMBLER, PENNSYLVANIA. Rees C. Roberts operated a drugstore in Ambler at Main Street and Butler Pike. The scene above, looking east on Butler Pike in the heart of downtown Ambler, shows his store in 1905. Roberts published local Ambler postcards and sold them in his store. Both views shown here are Rees Roberts postcards. While clearly promoting his own business in the view above, he was equally impressed with the scenic beauty of the Wissahickon Creek, as seen below. The drugstore changed names a few times before closing *c.* 1980. The building still stands today.

The Wissahickon at Ambler, Pa.

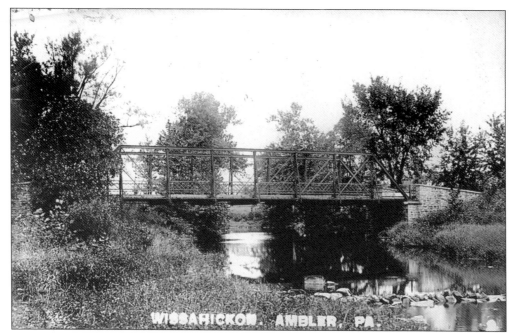

THE WISSAHICKON CREEK, AMBLER. Bridge crossings provide scenic views up and down the Wissahickon Creek, and many are found on old postcards. This scene shows what is most likely the old Mount Pleasant Avenue bridge over the Wissahickon, near Ambler. This bridge has been replaced by a concrete structure. (Bartholomew postcard.)

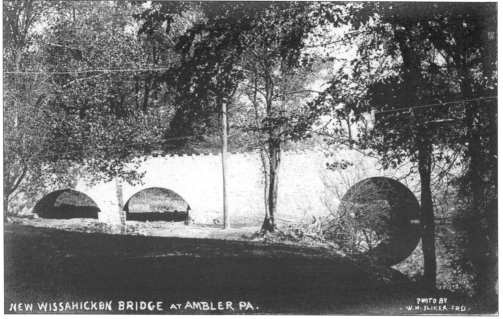

THE WISSAHICKON BRIDGE, AMBLER. This beautiful three-arch stone bridge carried Butler Pike over the Wissahickon Creek and was built in the 1800s. Butler Pike was first laid out in 1739 and became a turnpike in 1853. This bridge was replaced by a concrete span erected in 1926. (Sliker postcard.)

29

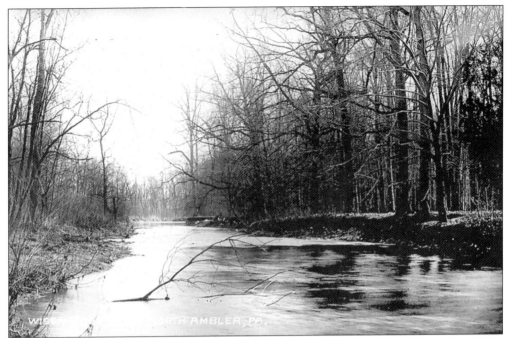

THE WISSAHICKON CREEK, NORTH AMBLER. North Ambler was located in the vicinity of Mount Pleasant Avenue, north toward Penllyn. This beautifully photographed postcard, by W. W. Miller of North Wales, shows the Wissahickon on a quiet winter day *c.* 1912.

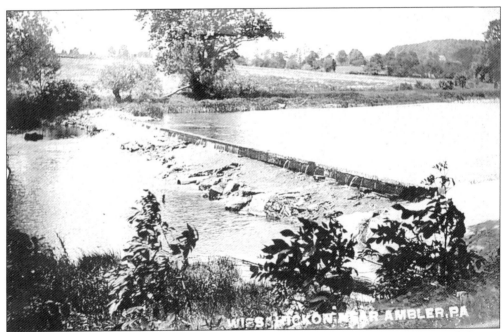

THE WISSAHICKON CREEK, AMBLER. The Wissahickon Creek is shown with a small dam in this view, near the vicinity of Mount Pleasant Avenue in Whitpain Township near Ambler. The creek complements this scenic country image from 1905 with plenty of open farmland in the distance. (Bartholomew postcard.)

THE WISSAHICKON CREEK, AMBLER. These views of the Wissahickon near Ambler were photographed by John Bartholomew, of Lansdale. The scenes from 1905 show the characteristic winding flow of the creek through the Montgomery County countryside.

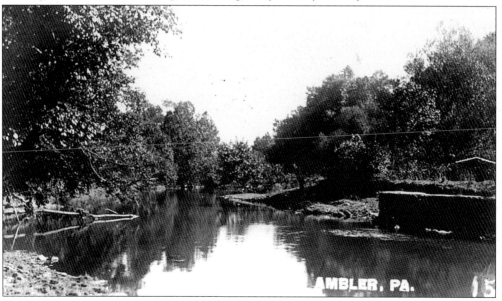

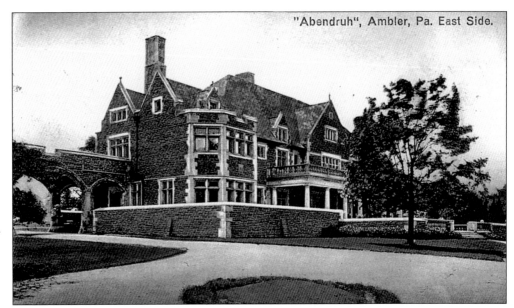

"Abendruh", Ambler, Pa. East Side.

ABENDRUH, AMBLER. This beautiful estate, only partially standing, is situated along Morris Road below Butler Pike, near the Wissahickon Creek. The house was built in the 1890s for Charles Bergner, of Bergner and Engel Brewing Company of Philadelphia. *Abendruh* is German for "evening's rest." Part of the acreage included a barn across Morris Road that now houses the Wissahickon Valley Watershed Association's Four Mills Nature Reserve headquarters. The Watershed Association is a nonprofit organization founded in 1957 to protect the quality and beauty of the Wissahickon Creek. The group has been very successful in land preservation in an area that has seen rapid suburban expansion. Protecting over 1,000 acres, the association offers a variety of environmental education programs. (Rees Roberts postcard, Ambler, Pennsylvania.)

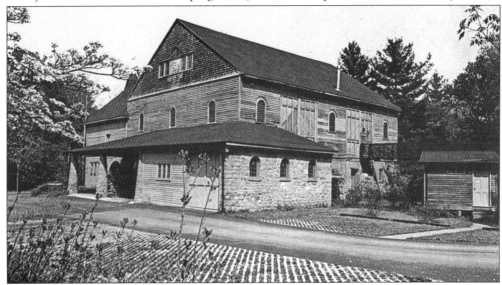

WISSAHICKON VALLEY WATERSHED ASSOCIATION. This postcard shows the Wissahickon Valley Watershed Association's headquarters, located in the 1891 barn built for Charles Bergner. Situated at 12 Morris Road, the barn was designed by well-known architect Horace Trumbauer. (Courtesy of the Wissahickon Valley Watershed Association.)

Three

THE WISSAHICKON,
FORT WASHINGTON TO
CHESTNUT HILL

**THE WISSAHICKON CREEK,
FORT WASHINGTON TO
CHESTNUT HILL.** As the
Wissahickon Creek passes below
Ambler, the relatively flat valley
is interrupted by a series of large,
imposing hills in the
Whitemarsh Valley. Now
known as Fort Hill, Militia Hill,
and Camp Hill, they rise high
above the creek and valley.
Some of the grounds on these
hills are preserved in Fort
Washington State Park and mark
the places where George
Washington's army established
encampments in 1777. This
chapter highlights this important
area and follows the creek down
to Flourtown and Chestnut Hill.

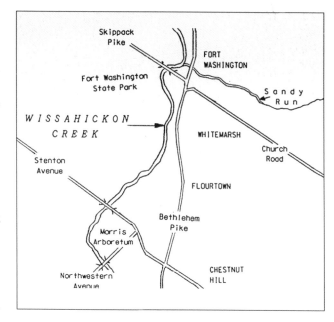

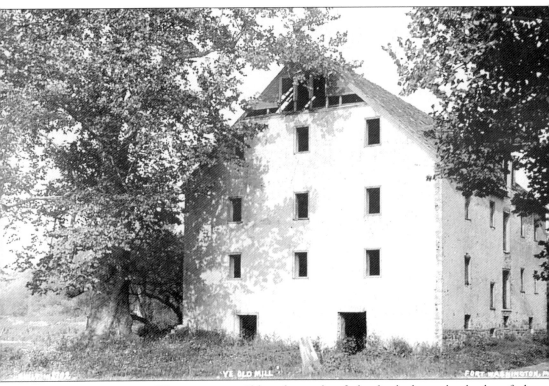

OLD MILL, FORT WASHINGTON. Although much of the land along the banks of the Wissahickon has been preserved, only a few of the many mills that once lined the creek now survive. Shown here in a view from 1910 is the Mather Mill, in Fort Washington. It is ideally situated along the creek near the junction of two important Colonial roads—the Skippack Pike and Bethlehem Pike. This building dates back to the 1820s and was erected by Joseph Mather. The Farmar family built an earlier mill on this site, possibly dating back to the late 1600s. In the mid-1700s, the Morris family of nearby Hope Lodge owned the mill. The Mathers owned the mill until 1848. Subsequent owners held the property until 1966, when it was given to the Commonwealth of Pennsylvania as a historic site. The mill is open to the public at special times. (Sliker postcard.)

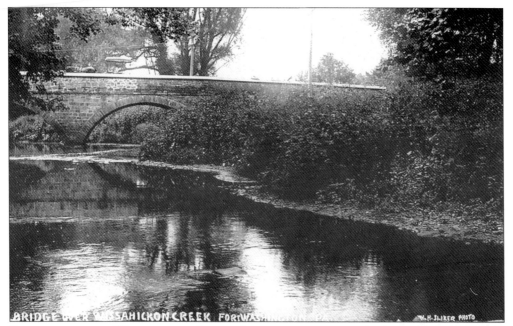

BRIDGE OVER THE WISSAHICKON CREEK, FORT WASHINGTON. This beautiful double-arched stone bridge is located near the Germantown Academy in Fort Washington and carries Morris Road over the Wissahickon. The bridge was built in the 1800s and was rebuilt in 1916, according to the date stone on the bridge. (Sliker postcard.)

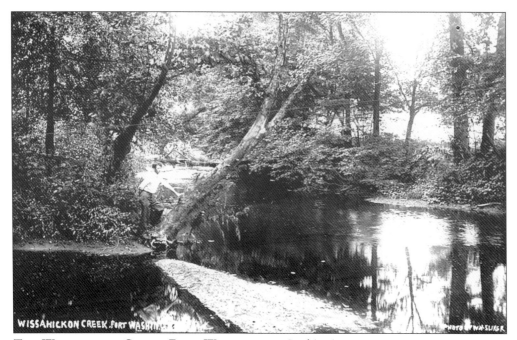

THE WISSAHICKON CREEK, FORT WASHINGTON. In this picture, a young man pauses near a bend along the picturesque Wissahickon Creek near Fort Washington *c.* 1910. (Sliker postcard.)

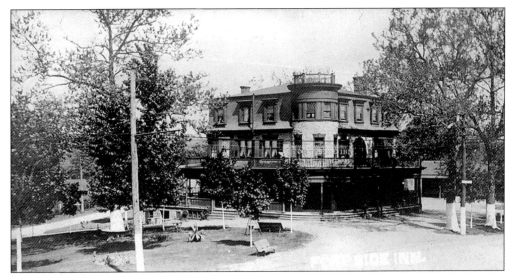

THE FORT SIDE INN. At the point where Skippack and Bethlehem Pike meet stands the Fort Side Inn. This Victorian-era inn's name commemorates George Washington's military forts at nearby Fort Hill, in Fort Washington. This view, most likely taken from atop the railroad bridge, shows Skippack Pike to the far left as it approaches the Wissahickon. Bethlehem Pike is shown in the foreground. The beautiful inn, with its elegant porches and widow's walk, is shown with various outdoor benches and represents a typical roadside tavern. Today, this building is known as the Bent Elbow Tavern. (Bartholomew postcard.)

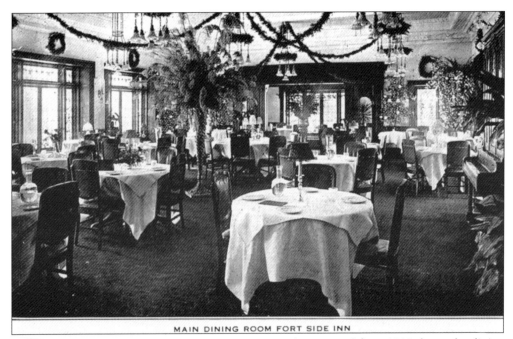

MAIN DINING ROOM FORT SIDE INN

THE MAIN DINING ROOM, THE FORT SIDE INN. This postcard from 1910 shows the dining room interior of the Fort Side Inn, in Fort Washington. Judging by the garland and wreaths shown here, the inn may have been decorated for the holidays.

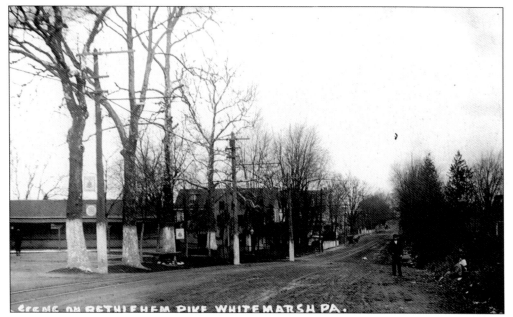

BETHLEHEM PIKE, WHITEMARSH. Bethlehem Pike is shown in a rare view looking north from the Skippack Pike intersection in Whitemarsh, prior to 1910. This important Colonial highway dates from *c.* 1700 and most likely followed the course of an old Native American path. Much of this road parallels the Wissahickon Creek through lower Montgomery County. Horse sheds on the left side of this view belonged to the Fort Side Inn. (Sliker postcard.)

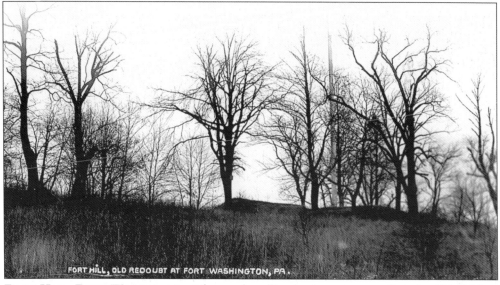

FORT HILL, FORT WASHINGTON. The gently rolling landscape surrounding the Wissahickon Creek in Montgomery County is interrupted by a series of hills rising above the Whitemarsh Valley near Fort Washington. Known as Camp Hill, Militia Hill, and Fort Hill, they have great historical importance, as they were occupied by George Washington's army during the Revolutionary War. Being the highest points in the area, they were used as strategic lookouts and forts during the American Revolution. Fort Hill, now a section of Fort Washington State Park, is located off Bethlehem Pike. (Miller postcard.)

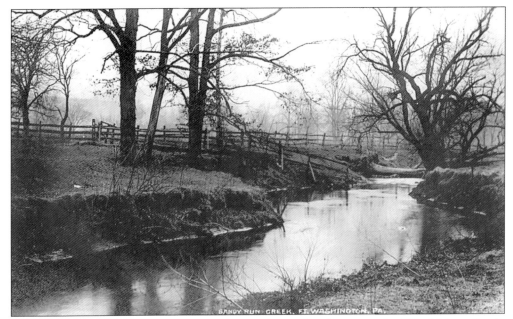

SANDY RUN, FORT WASHINGTON. Sandy Run is a main tributary to the Wissahickon Creek. The stream originates near Abington and meanders through lower Montgomery County to the Wissahickon at Fort Washington. Perhaps named after the sandlike soil of the area, the stream is known to overflow its banks easily during rainstorms. Shown in this view is the picturesque Sandy Run near Fort Washington on an overcast winter day. (Miller postcard.)

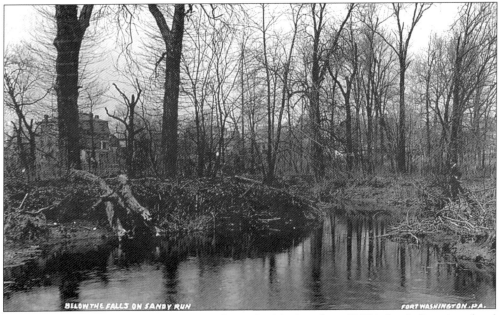

ON SANDY RUN, FORT WASHINGTON. Shown in this view from 1915 is Sandy Run just ahead of where it enters the Wissahickon Creek. In the background through the wooded area are buildings along Bethlehem Pike in the village of Fort Washington. Most of this area surrounding both creeks is now part of county parklands. (Sliker postcard.)

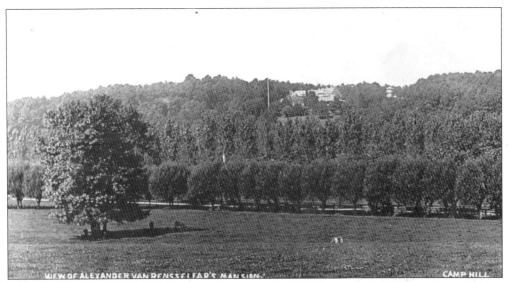

ALEX VAN RENSSELEAR'S MANSION, CAMP HILL. Rising above the Wissahickon Valley is Camp Hill. It was an army camp during the Revolutionary War. Its strategic position as one of the highest hills in the area enabled George Washington's troops to have a commanding view of the whereabouts of the British army. The Van Rensselear mansion, seen in the center, was built on the top of Camp Hill in 1889 and was named Camp Hill Hall. The open pasture in the foreground is now occupied by the Sandy Run Country Club. Sandy Run is hidden under the row of trees beyond the pasture. The image dates from 1910. (Sliker postcard.)

SANDY RUN, FORT WASHINGTON. This 1915 scene shows Sandy Run in the vicinity of Camp Hill Road near the present-day Sandy Run Country Club, in Springfield Township. Beautiful scenery such as this is characteristic of the Wissahickon area near Fort Washington. (Miller postcard.)

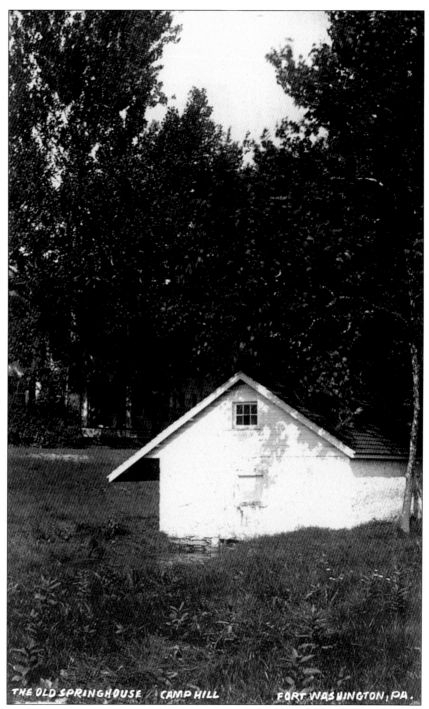

THE OLD SPRINGHOUSE / CAMP HILL FORT WASHINGTON, PA.

THE OLD SPRINGHOUSE, FORT WASHINGTON. Much, if not all, of the Wissahickon Creek watershed is fed by natural underground springs. Early settlers to the area erected springhouses over the springs. They acted as refrigerated storage structures. The spring water was a cool temperature all year long. This view shows a typical early springhouse that fed a portion of Sandy Run near Fort Washington. (Sliker postcard.)

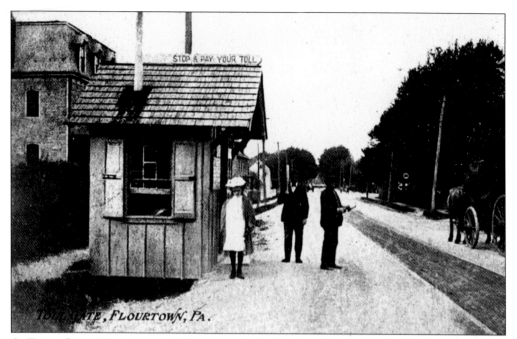

A Toll Gate, Flourtown. Flourtown is the largest village along Bethlehem Pike, below Ambler. Dating back to the 1780s, the village's existence is tied directly to the Wissahickon Creek. Early mills erected along the constantly flowing waters of the Wissahickon attracted local farmers, who brought their grain to be ground into flour—hence the name Flourtown. This view from *c.* 1900 shows a tollgate along Bethlehem Pike. Tolls were collected along the pike from 1804 until the early 1900s.

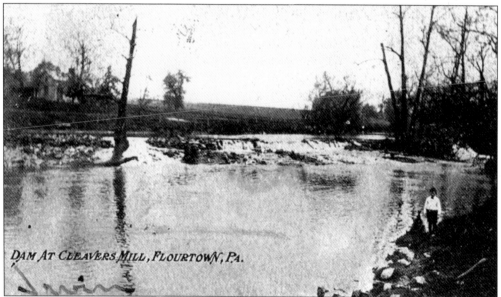

The Cleaver Milldam, Flourtown. One of the mills that was used to grind grain was the Cleaver Mill, near Flourtown. Dams were usually constructed near mills to aid in water retention and power. The Cleaver Mill and the dam were located along the Wissahickon Creek near Stenton Avenue.

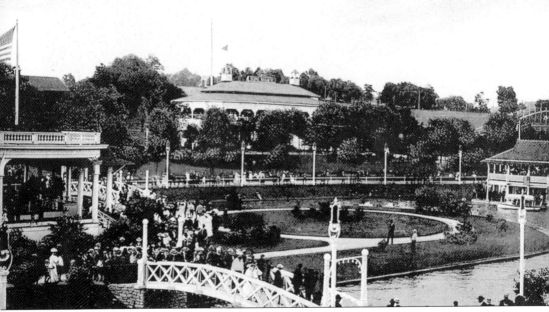

WHITE CITY. Once situated along Paper Mill Run, a tributary to the Wissahickon Creek, was White City, or Chestnut Hill Amusement Park. From 1898 to 1911, the park offered the public a wide variety of activities and amusements. Centrally located in the park was Yeakle's Pond, also known as Hillcrest Pond. Hillcrest Pond offered boating, as shown in the 1910 view. Paper Mill Run is named after a paper mill that was located near Paper Mill Road in Springfield Township.

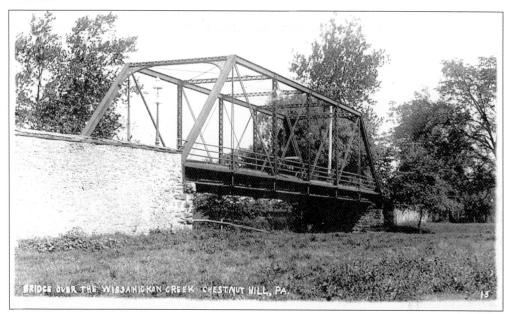

A Bridge over the Wissahickon Creek, Chestnut Hill. An old iron-truss bridge attached to stone abutments is shown spanning the Wissahickon Creek near Chestnut Hill. This bridge is no longer standing, and its location remains a mystery. Most likely, it is the Northwestern Avenue bridge over the creek. The view dates from 1910. (Sliker postcard.)

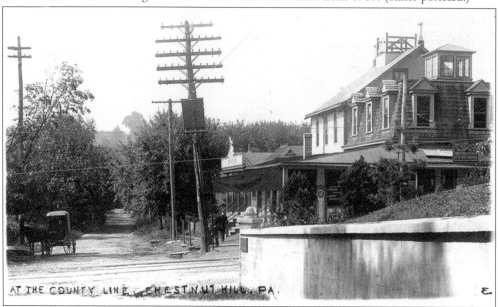

At the County Line, Chestnut Hill. This view looks south on Northwestern Avenue from the Germantown Avenue intersection in Chestnut Hill. To the left is part of Wissahickon Park where the Northwestern Equestrian Stables are located. To the right are two buildings that are still standing. The one closest to Germantown Avenue with the fancy mansard roof was occupied by a luncheonette in 1909 and offered "quick lunch, tea, chocolate, confections, ice cream, and soft drinks." Today, this building still serves as a restaurant and offers refreshments. (Sliker postcard.)

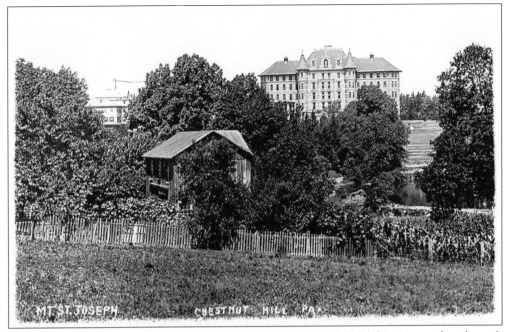

CHESTNUT HILL COLLEGE. As the Wissahickon Creek enters Philadelphia, it meanders through the grounds of Chestnut Hill College, at Northwestern and Germantown Avenues. Originally founded as Mount St. Joseph's Academy in 1871, it later became Chestnut Hill College in 1924. This 1914 scene shows the creek to the extreme right with the college buildings rising above the trees. (Sliker postcard.)

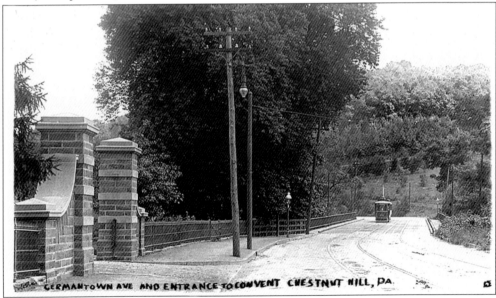

GERMANTOWN AVENUE, CHESTNUT HILL. A single trolley passes over the Wissahickon Creek along Germantown Avenue in a view looking east from Chestnut Hill College. The rise of the ground behind the trolley is the highest elevation in Philadelphia and was named Chestnut Hill due to the abundant Chestnut trees that once inhabited the area. In this 1914 view, a beautiful stone entrance to the college is shown on the left. (Sliker postcard.)

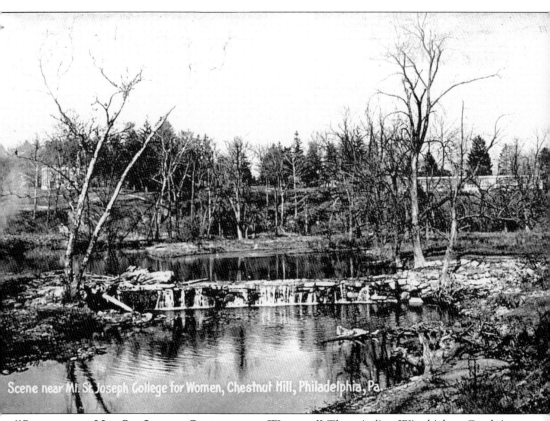

Scene near Mt. St. Joseph College for Women, Chestnut Hill, Philadelphia, Pa.

"SCENE NEAR MT. ST. JOSEPH COLLEGE FOR WOMEN." The winding Wissahickon Creek is seen in a 1905 view with a small waterfall, near Chestnut Hill College. The relatively flat landscape of this area changes as the creek winds its way into the gorgelike valley of Fairmount Park. (Rotograph postcard.)

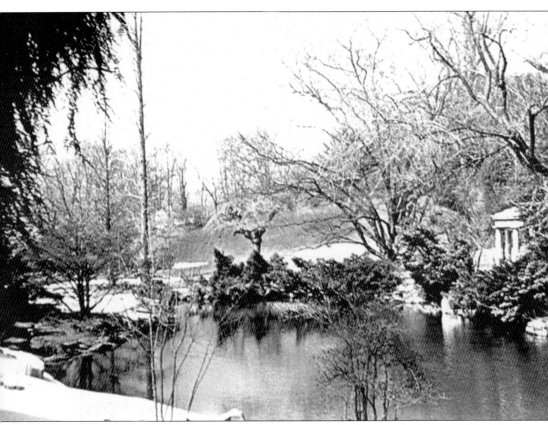

THE SWAN POND, THE MORRIS ARBORETUM. Bordering the Wissahickon Creek in Chestnut Hill is the Morris Arboretum of the University of Pennsylvania. Brother and sister John and Lydia Morris built an estate called Compton on this site in 1887. Soon after, they journeyed abroad to collect some of the world's most beautiful plants. The result was the creation of a lovely Victorian-style garden. In 1932, the garden came into the possession of the University of Pennsylvania and became the Morris Arboretum. The beautiful garden, statuary, and Swan Pond seen here are open to the public.

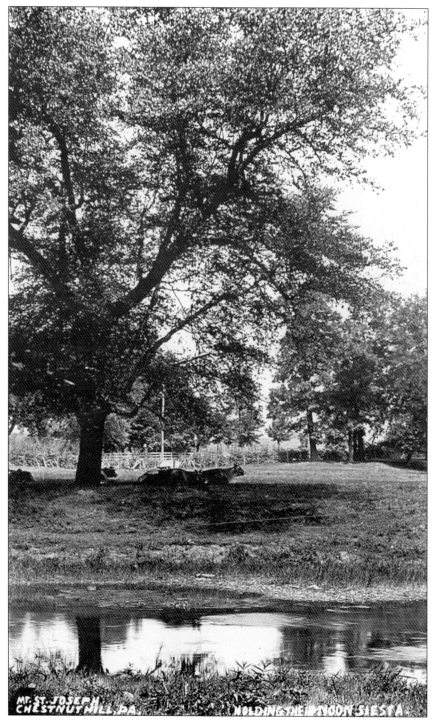

MOUNT ST. JOSEPH'S ACADEMY, CHESTNUT HILL. The caption on this 1914 postcard reads, "Holding their noon siesta." This refers to the napping cows enjoying a cool spot under a large tree on a sunny summer day. The Wissahickon is shown in the foreground. Beautiful images such as this one preserve the once pastoral quality of the area. (Sliker postcard.)

THE BEAUTIFUL WISSAHICKON
CHESTNUT HILL, PA.
#2.

THE WISSAHICKON CREEK. A glimpse of the calm Wissahickon in Chestnut Hill reveals a gently rolling landscape and gives no clue to the rugged and hilly terrain that follows as the creek makes its way down the valley to the Schuylkill River. The postcard dates from 1914. (Sliker postcard.)

Four

ALONG THE

FORBIDDEN DRIVE

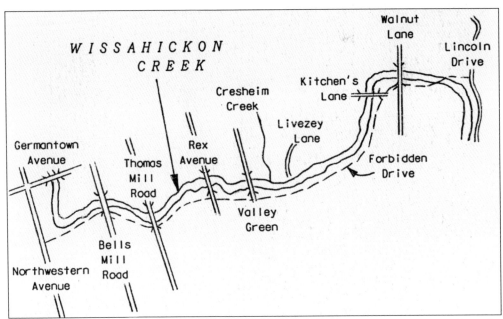

ALONG THE FORBIDDEN DRIVE. Illustrated in this chapter is the most scenic area along the Wissahickon Creek. It follows the Forbidden Drive from near Northwestern Avenue to Lincoln Drive. In this area, the Wissahickon rambles through a beautiful gorgelike valley, passing numerous historic buildings and bridges before taking a sharp bend toward the Schuylkill River.

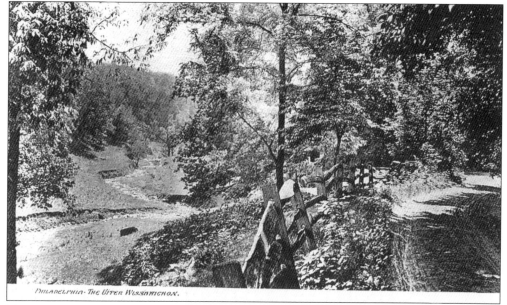

Philadelphia - The Upper Wissahickon.

THE UPPER WISSAHICKON. Beyond the Wissahickon gorge and the city limits of Philadelphia, the creek valley is much flatter. Its flatness is illustrated in this 1906 view, somewhere along the Wissahickon above Chestnut Hill. This area is characterized by gently rolling slopes and hills. (World Postcard Company postcard.)

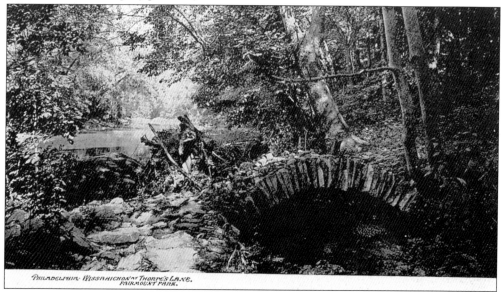

Philadelphia - Wissahickon at Thorps Lane. Fairmount Park.

THE WISSAHICKON AT THORP'S LANE. Many bridges and mills erected along the lower Wissahickon over the past two centuries have been known by various names. Mill names changed when owners sold them to other families. Thorp's Lane was named after mill owner Issachar Thorp in the 1830s. Daniel Howell built an original mill in the 1700s, and it later became the possession of the Paul family, until 1801. From 1801 until 1832, James and John Bell owned the mill, and it was known as Bells Mill, which is the name used today. This view from 1905 shows the ruins of what might be the millrace at the creek's edge. All the mills that were once located in the park were demolished by the city in the 1800s. (World Postcard Company postcard.)

50

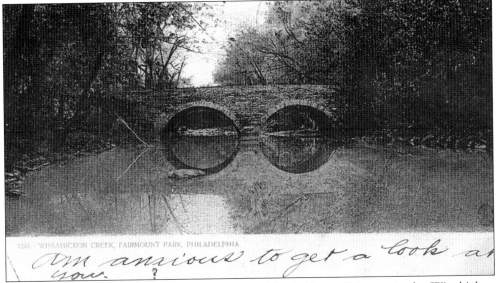

am anxious to get a look at you. ?

THE BELLS MILL ROAD BRIDGE. One of the oldest bridges still in use in the Wissahickon Valley carries Bells Mill Road over the creek. Named after mill owners James and John Bell, the bridge bears a date stone reading, "County Bridge built 1820." It is a twin-arch bridge built of native stone and erected by Philadelphia County. The area was part of Philadelphia County but not part of the city at that time. It was not until 1854 that the county and city consolidated.

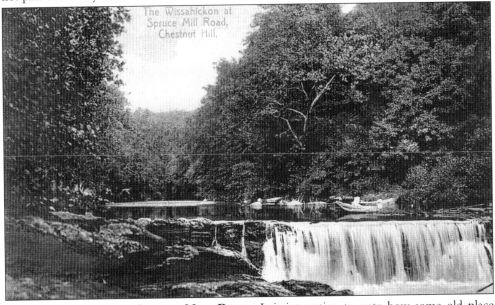

The Wissahickon at Spruce Mill Road, Chestnut Hill.

THE WISSAHICKON AT SPRUCE MILL ROAD. It is interesting to note how some old place names remain, while others fade away. Such is the case with the above view, showing an old milldam along the Wissahickon at Spruce Mill Road. In the 1730s, Spruce Mill Road was laid out, connecting Roxborough to Chestnut Hill. The name was changed to Barge's Mill Road and eventually to the Thomas Mill Road in 1784. In this 1909 postcard, photographer Philip Moore identifies the spot by its original name, not by its more common or current name, Thomas Mill Road. Today the dam may be viewed along the Wissahickon immediately north of the Thomas Mill Covered Bridge. Over time, the name Spruce Mill has almost vanished.

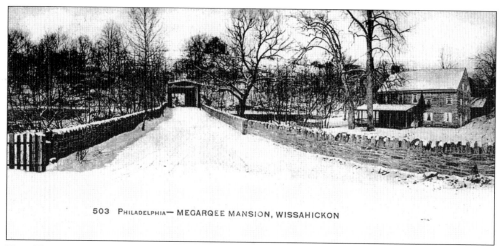

503 PHILADELPHIA— MEGARQEE MANSION, WISSAHICKON

THE THOMAS MILL COVERED BRIDGE. In this 1906 image, the Thomas Mill Covered Bridge is viewed looking west in a snow-covered landscape. The house shown to the right was part of a mill complex that no longer exists. Many names have been associated with the mill and the house located near the bridge. The Barge family owned the property until 1784. After that time, Daniel Thomas owned the mill until 1839. Edward Megargee owned the property until 1859, and it was acquired by Fairmount Park a few decades later. (World Postcard Company postcard.)

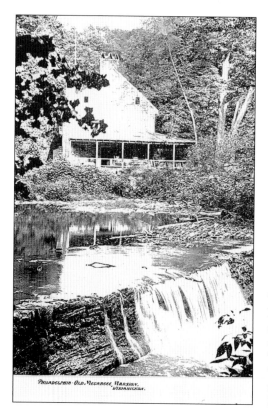

PHILADELPHIA · OLD MEGARGEE MANSION. WISSAHICKON.

THE OLD MEGARGEE MANSION. The Barge-Thomas-Megargee mansion, located along the Wissahickon Creek in front of the old milldam, is shown in a 1906 view. The dam still exists upstream from the Thomas Mill Covered Bridge, but the mansion no longer stands. (World Postcard Company postcard.)

PHILADELPHIA - THE WISSAHICKON.
BELOW MEGARGEE LANE.

THE WISSAHICKON BELOW MEGARGEE LANE. To the right in this 1906 view is the beautiful Thomas Mill Covered Bridge spanning the Wissahickon, with the Forbidden Drive shown in the foreground. Sources state that an original covered bridge was erected in the mid-1700s. The Thomas Mill Bridge remains the only covered bridge in Philadelphia and is reputed to be the only covered bridge in a major U.S. city. Megargee is the name of an old family that occupied land near the bridge. The bridge was restored a few years ago and remains a favorite spot in the park. (World Postcard Company postcard.)

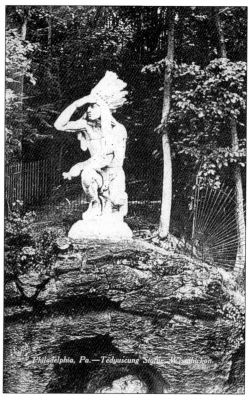

THE TEDYUSCUNG STATUE. Situated on the east side of the creek a mile north of Valley Green is a large statue of the Native American Tedyuscung. Erected in 1902 through the generosity of local citizens Mr. and Mrs. Charles Henry, the statue commemorates the man believed to be the last Native American chief in the Wissahickon Valley. The picturesque setting atop a rocky cliff is often referred to as Indian Rock, or Council Rock. The statue is often overlooked and somewhat obscured by dense trees along the Forbidden Drive, but a recently installed plaque informs park visitors of its location and significance. (World Postcard Company postcard.)

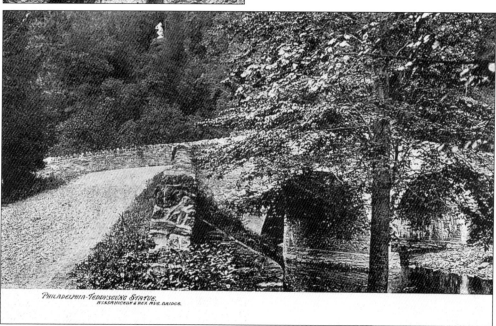

THE TEDYUSCUNG STATUE AND REX AVENUE BRIDGE. This 1905 view shows Tedyuscung overlooking the Wissahickon Creek and the Rex Avenue Bridge. Park visitors today can stand in this exact spot and view the creek and bridge, although the Tedyuscung statue is hidden behind dense forest growth. (World Postcard Company postcard.)

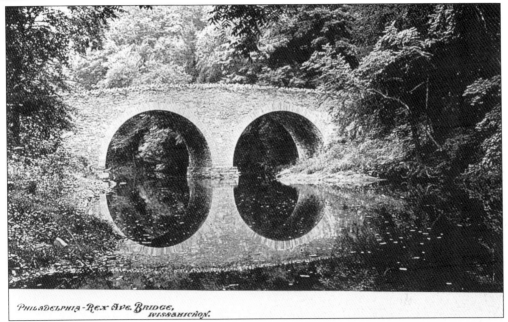

PHILADELPHIA-REX AVE. BRIDGE, WISSAHICKON.

THE REX AVENUE BRIDGE. As early as 1769, Abraham Rex is listed as a taxpayer in the German Township, also known as Chestnut Hill. In 1850, a road was opened from the Wissahickon to the land of George Rex, and around that time the Rex Avenue Bridge was constructed. Commemorating the old family name, the bridge remains a beautiful spot in the park. Its picturesque arches reflect wonderfully in the Wissahickon. This view dates from 1905. (World Postcard Company postcard.)

THE BRIDLE PATH TO INDIAN ROCK. Unlike the rather wide and level Forbidden Drive that parallels the creek on the west side, rugged, narrow, and hilly trails and paths dominate the east side. This 1905 view shows the rustic bridle path approaching Indian Rock, lined with mature hemlocks and tulip poplars. (World Postcard Company postcard.)

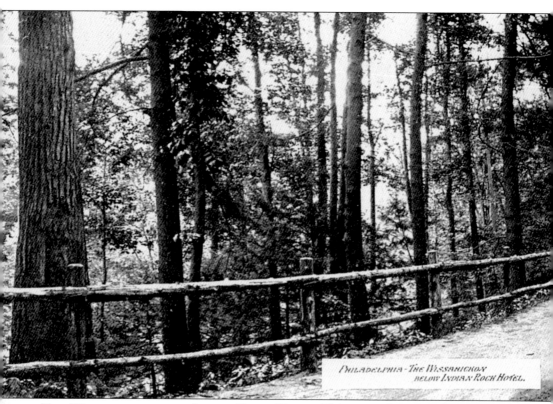

Philadelphia - The Wissahickon
below Indian Rock Hotel.

THE WISSAHICKON BELOW INDIAN ROCK HOTEL. This postcard is part of a series of folded double-size views and shows the Forbidden Drive below Rex Avenue. Along the path toward the right stands a public water fountain. A series of fountains fed by spring water were erected along the Wissahickon in the 1850s. This fountain bears the date 1854 and is inscribed with the Latin

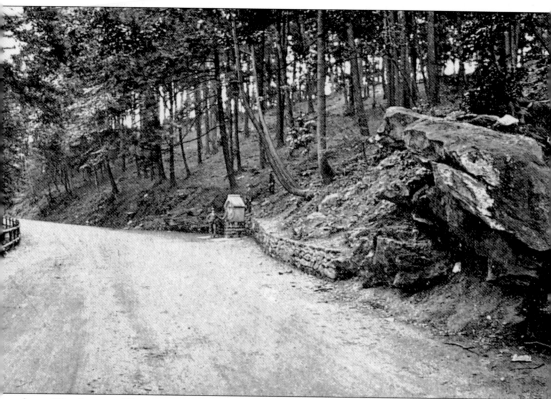

phrase "Pro bono publico, este perpetua." Translated, this phrase means "For the public good, let it remain forever." In this case, forever meant about 100 years. In the late 1950s, all fountains were sealed off due to poor water quality. However, the fountain structures remain a reminder of the past, when the Wissahickon water was pure and refreshing. (World Postcard Company postcard.)

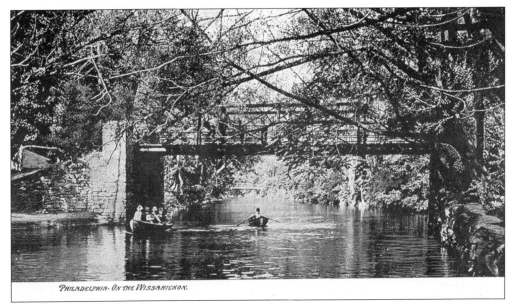

PHILADELPHIA· ON THE WISSAHICKON.

THE HARTWELL AVENUE (LANE) BRIDGE. Today's Hartwell Lane runs east and west from Germantown Avenue. However, the bridge shown here crossing the Wissahickon no longer stands. Evidence of this structure can still be found, as the approaches to the bridge can be seen along the Forbidden Drive north of Valley Green. Originally known as Weiss's (Wise) Mill Road, the section of the road east of the creek was renamed Hartwell Lane when Hiram Hartwell settled a large tract of land in the mid-1800s. In this 1906 view, boaters enjoy a day in the park. (World Postcard Company postcard.)

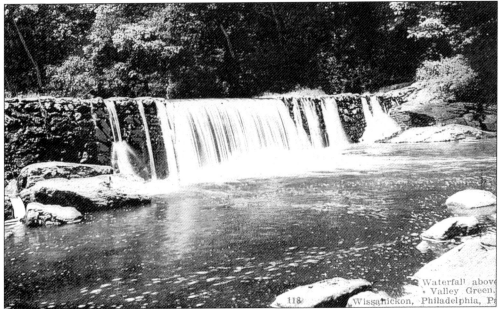

Waterfall above Valley Green, Wissahickon, Philadelphia, Pa

118

A WATERFALL ABOVE VALLEY GREEN. One of the numerous scenic waterfalls along the Wissahickon Creek is located upstream from Valley Green. Various dams and waterfalls greatly enhance the beauty of the park. This dam, known as Magarge Dam, powered the Magarge Mill, which discontinued operation in 1883.

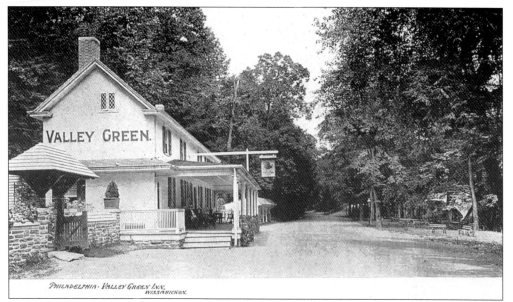

THE VALLEY GREEN INN. The most popular landmark and meeting place in the Wissahickon Valley is the Valley Green Inn. The inn was built in the 1850s specifically for travelers and visitors along the Forbidden Drive. Remarkably, this view from 1905 looks almost identical to what one sees today. (World Postcard Company postcard.)

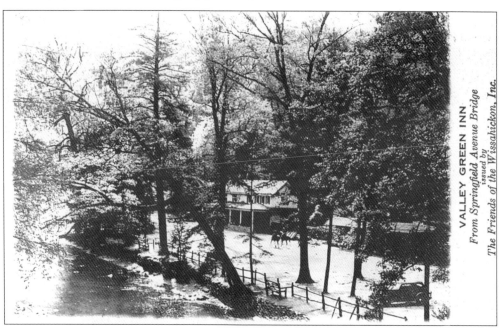

THE VALLEY GREEN INN. The Valley Green Inn is shown in this 1940 view from atop the Valley Green Bridge. This postcard is part of a small series that was published by the Friends of the Wissahickon. The Friends of the Wissahickon, established in 1924, consists of nearly 1,200 members. The group sponsors cleanup days along the creek, as well as lecture series and trail restoration. The small staff and 28-member board are hardworking and passionate about preserving the Wissahickon for future generations.

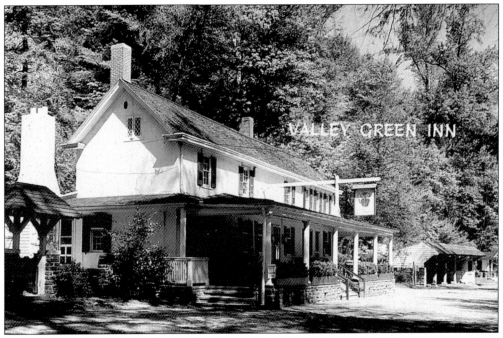

THE VALLEY GREEN INN. This 1960 image is strikingly similar to the 1905 view and confirms that the Valley Green Inn has changed little in the past 100 years. (Wyco postcard.)

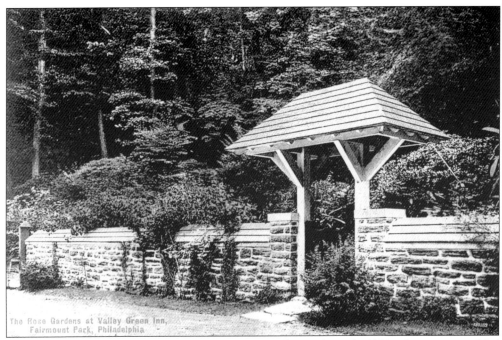

The Rose Gardens at Valley Green Inn,
Fairmount Park, Philadelphia

THE ROSE GARDEN AT VALLEY GREEN. It appears that in the early 1900s, there was an added attraction to Valley Green—a rose garden built alongside the inn. This garden wall and covered gateway still exist along the Forbidden Drive south of the inn. This postcard dates from 1909. (Moore postcard.)

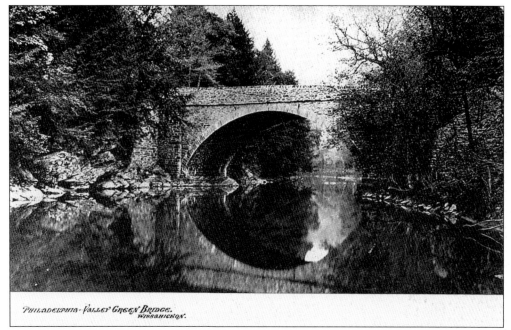

Philadelphia - Valley Green Bridge.
Wissahickon.

THE VALLEY GREEN BRIDGE. Further enhancing the beauty of the Valley Green area is the lovely bridge located several hundred feet above the inn. Built in 1832 and rebuilt in 1915, the bridge leads to Springfield Avenue and was also known as the Springfield Avenue Bridge. Wonderful views of the creek and surrounding valley can be seen from both directions atop the bridge. This postcard dates from 1905. (World Postcard Company postcard.)

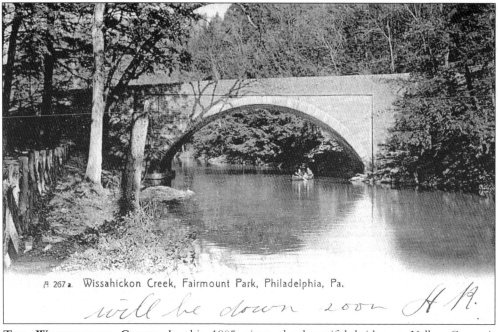

A 267 a. Wissahickon Creek, Fairmount Park, Philadelphia, Pa.

THE WISSAHICKON CREEK. In this 1905 view, the beautiful bridge at Valley Green is brilliantly accented by the summer sunlight and creek reflections set amid a lush forest valley. (Rotograph postcard.)

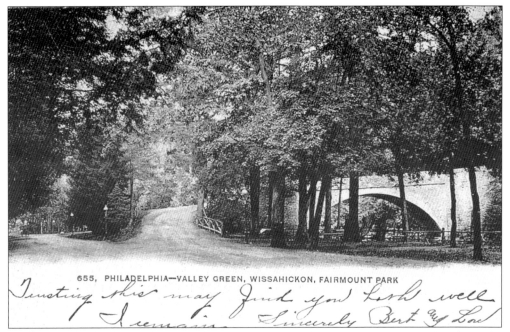

655, PHILADELPHIA—VALLEY GREEN, WISSAHICKON, FAIRMOUNT PARK

Trusting this may find you look well I remain Sincerely Bert and Lou

THE VALLEY GREEN BRIDGE. This 1905 scene shows the Valley Green Bridge from the perspective of standing in front of the Valley Green Inn. To the far left is the Forbidden Drive, the main pathway of the park. Not much has changed at this spot in the last 100 years.

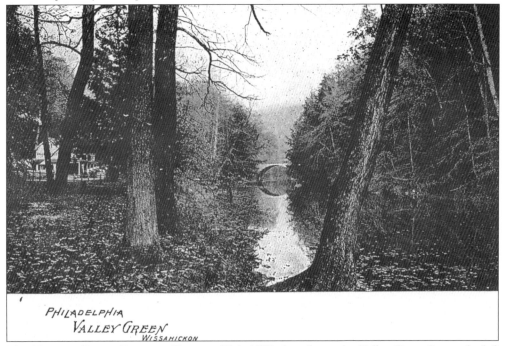

PHILADELPHIA
VALLEY GREEN
WISSAHICKON

THE VALLEY GREEN INN AND BRIDGE. This 1905 view shows the Valley Green Inn to the left and the Valley Green Bridge in the distance with the beautiful Wissahickon Creek surrounded by tall trees. The Valley Green area is the most popular gathering spot in the park. (World Postcard Company postcard.)

THE WISSAHICKON CREEK AT VALLEY GREEN. The Valley Green area along the Wissahickon is quite beautiful, and there are numerous views depicting this vicinity. With the bridge in the far distance, large trees arch over and reflect in the creek. This view dates from 1910. (Bunnell postcard.)

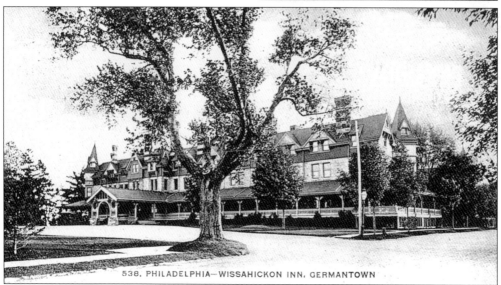

538. PHILADELPHIA—WISSAHICKON INN, GERMANTOWN

THE WISSAHICKON INN. For a period in the mid- to late 1800s, several individuals believed that the scenic Wissahickon Valley could become a summer resort destination for city people. Henry Houston, a large real estate holder in Chestnut Hill, built the Wissahickon Inn in 1884. An earlier inn from the 1860s had burned down in the 1870s. The inn was designed by Philadelphia architects George and William Hewitt in the fashionable Queen Anne style, complete with assorted turrets, gables, and porches. The large 250-room Wissahickon overlooked the valley from West Willow Grove Avenue and never gained widespread popularity. By 1900, it was being used by the Chestnut Hill Academy for their school, which still occupies it today.

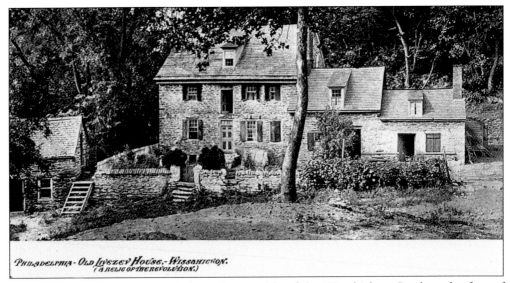

THE LIVEZEY HOUSE. Located along the east side of the Wissahickon Creek at the foot of Livezey Lane is Glenfern, the Livezey House. In the past, there have been numerous accounts pertaining to the date and occupancy of this home. Previous sources have noted that the house was erected in the 1680s and was occupied by George Washington at one time. The exact date of construction may be unclear; however, what is known is that the home, along with a mill, was built by Thomas Shoemaker and sold to Thomas Livezey *c.* 1747. The mill that was once part of this property was torn down many years ago. The architecturally unique home was headquarters for a local canoe club for decades and is now maintained by the Fairmount Park Commission. (World Postcard Company postcard.)

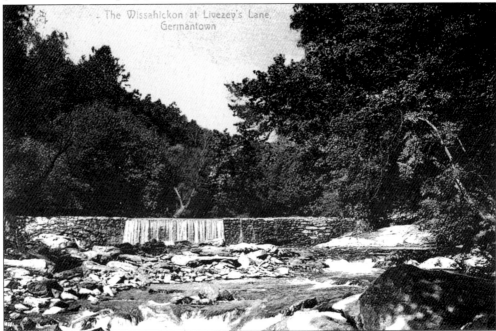

LIVEZEY'S DAM. A remnant of the old mill is Livezey's Dam, seen here in a view from 1909. It is situated along the Wissahickon Creek next to Glenfern. (Moore postcard.)

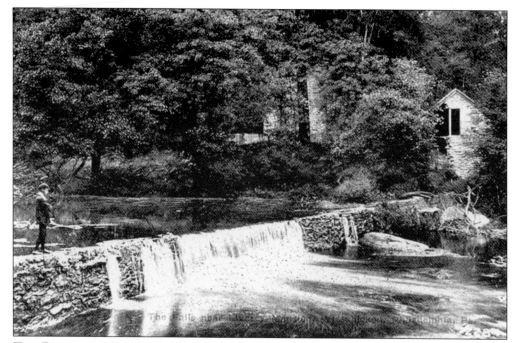

THE FALLS NEAR LIVEZEY'S MANSION. This 1909 postcard shows the Livezey Dam along the Wissahickon as viewed from the Forbidden Drive. At that time, there were still several old ruins (partial structures) that were once part of the Livezey Mill complex, none of which survive today.

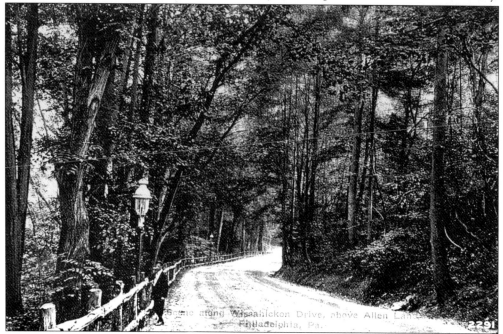

WISSAHICKON DRIVE ABOVE ALLENS LANE. The scenic Forbidden Drive, paralleling the Wissahickon Creek for miles, offers park visitors a wide smooth trail to follow. People today can still roam this beautiful drive beneath a canopy of soaring mature trees, as seen in this 1907 view. Here a young man pauses near an old gas lamp along the drive.

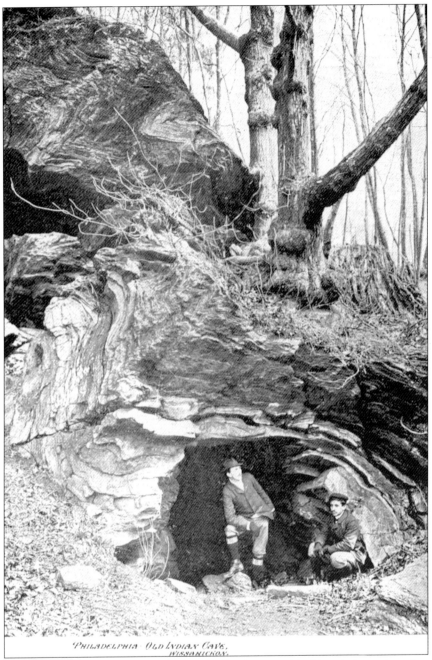

PHILADELPHIA - OLD INDIAN CAVE,
WISSAHICKON.

THE OLD INDIAN CAVE. The Wissahickon Valley is steeped in historic legends and romantic lore. From Native American chiefs to hermits practicing mysticism, many tales have been recorded through the last three centuries. This old cave, believed to have been occupied by Native Americans, was located along the Gorgas Lane path up from the Forbidden Drive. There is also a story that some of the caves in this area have buried treasure. The Wissahickon Valley contains abundant areas of large and beautiful rock formations, some rising quite high above the creek. Seen in this 1905 image are interesting ridges and curves that formed around the cave. Two park hikers pause at the cave entrance. (World Postcard Company postcard.)

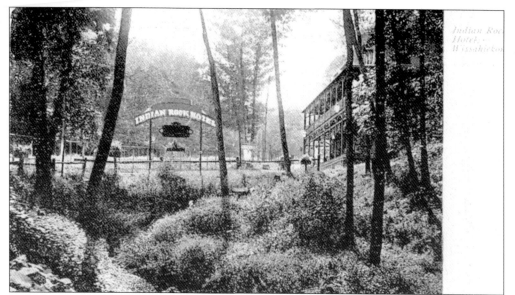

THE INDIAN ROCK HOTEL. The Indian Rock Hotel is one of a few inns that lined the banks of the Wissahickon and has since faded into obscurity. The original inn was built in the 1800s across from Indian Rock, where the Tedyuscung statue now stands. This structure was torn down, and another Indian Rock Hotel was built farther downstream near the foot of Monastery Avenue. That building has also been demolished. Shown here, a sign attracts visitors to the large hotel that contained two levels of balconies offering visitors views of the Wissahickon.

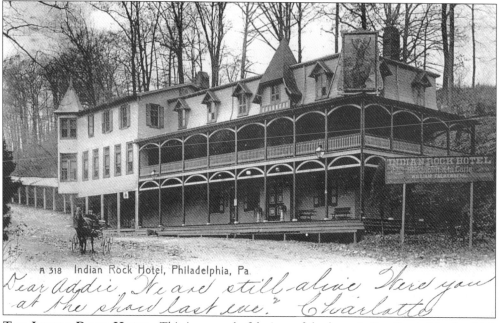

A 318 Indian Rock Hotel, Philadelphia, Pa.

THE INDIAN ROCK HOTEL. This is a wonderful view of the large Indian Rock Hotel, which was once situated along the Wissahickon. This postcard identifies the hotel proprietor as William Falkenburg and advertises the inn as "Restaurant a la Carte." Also shown above the second floor balcony, though not very clear, is an old painted tavern sign of a Native American kneeling on a rock. A nice horse-drawn carriage is shown to the left of this 1905 view. (Rotograph postcard.)

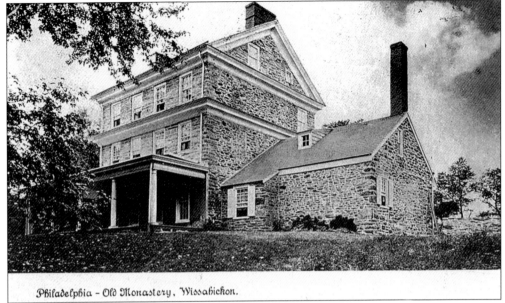

Philadelphia - Old Monastery, Wissahickon.

THE OLD MONASTERY AT KITCHEN'S LANE. This large three-story stone building, shown in a 1906 view, stands high on a hilltop overlooking the Wissahickon Creek at Kitchen's Lane. Erected *c.* 1750 by George Gorgas, the building was the center of a religious following that held baptisms in the Wissahickon in an area referred to as Baptismal Pool. Acquired by Fairmount Park in 1896, the monastery still stands and its barns serve as horse stables for the park. (World Postcard Company postcard.)

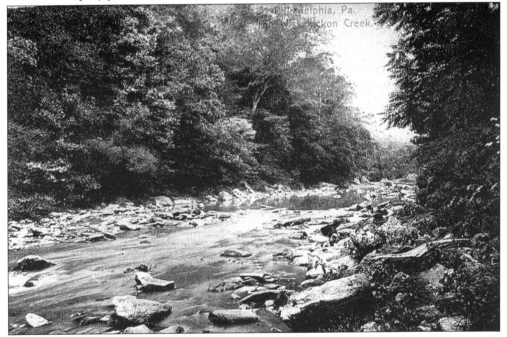

THE WISSAHICKON CREEK. In the summer, when the flow in the creek is at its lowest, beautiful rocks that are hidden beneath the waters are revealed in shallow places. This 1905 view shows the rocky creek bed near Kitchen's Lane.

WISSAHICKON CREEK AT KITCHEN'S LANE. One of the most rugged and beautiful areas along the Wissahickon Creek is at Kitchen's Lane. Here, the creek takes a dramatic sharp turn with scenic hills rising high on both sides of the stream. Philip Moore captures these two images on postcards from 1910.

THE STATUE *TOLERATION*. In the vicinity of Kitchen's Lane across the creek from the Forbidden Drive stands a statue called *Toleration*. The statue was erected in 1883 by John Welsh, a former member of the Fairmount Park Commission who lived near this area along Wissahickon Avenue on an estate called Spring Bank. *Toleration* stands atop Mom Rinker's Rock in a picturesque, rocky area. Legend states that Mom Rinker was a witch during the Revolutionary War. The statue resembles William Penn, and the base of the figure is simply inscribed, "Toleration." John Welsh donated the Mom Rinker's Rock area to Fairmount Park prior to his death in 1886.

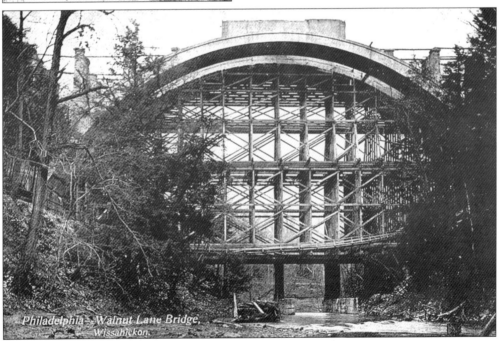

THE WALNUT LANE BRIDGE. The beauty of the Wissahickon Valley, with its old trees, rocky cliffs, and meandering creek, is enhanced by the majestic and graceful Walnut Lane Bridge. In this rare view of bridge construction from 1905, intricate scaffolding is shown as the bridge rises above the creek. (World Postcard Company postcard.)

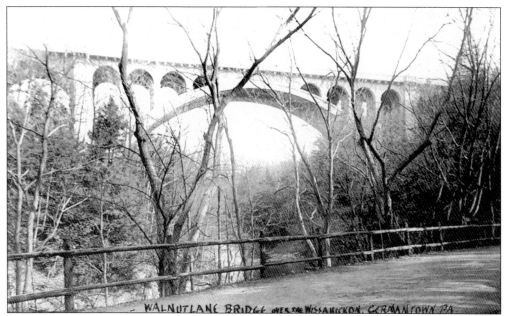

THE WALNUT LANE BRIDGE. Almost 600 feet long and soaring over 130 feet above the creek, the Walnut Lane Bridge was an engineering and architectural marvel when built in 1906. Considering the mammoth size of this man-made intrusion in the park, the bridge surprisingly does not overpower or destroy the natural scenery. Rather, it enhances the scenic quality of the valley. The Walnut Lane Bridge remains a true balance between man and nature. In this postcard from 1909, one gets a beautiful view of it from the Forbidden Drive. (Sliker postcard.)

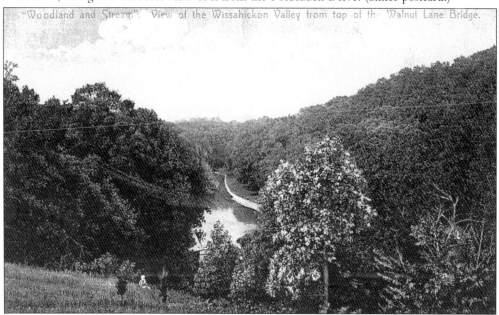

"WOODLAND AND STREAM," THE WISSAHICKON VALLEY FROM THE WALNUT LANE BRIDGE. Recognizing the great vantage point of the Wissahickon Valley from atop the Walnut Lane Bridge, Philip Moore produced this postcard in 1907. This scene offers a great bird's-eye view of the valley.

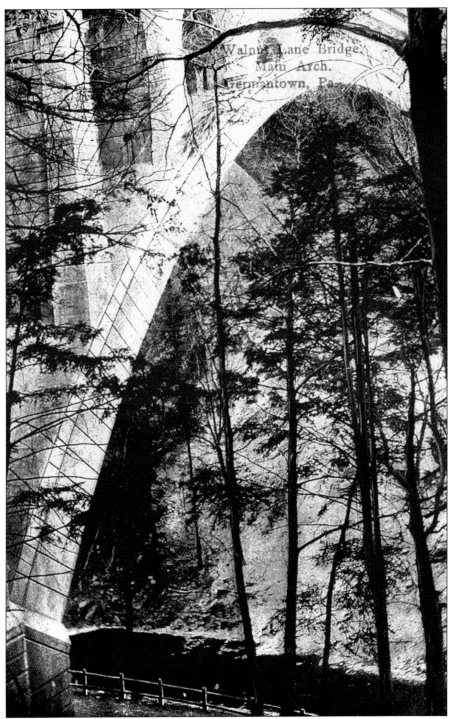

The Walnut Lane Bridge, Main Arch. This postcard, taken from another angle partway up an embankment, shows the massive main arch of the Walnut Lane Bridge rising above the Forbidden Drive and creek, dwarfing the tallest trees. This dramatic view reveals the bridge's graceful beauty amid the foliage of the Wissahickon Valley.

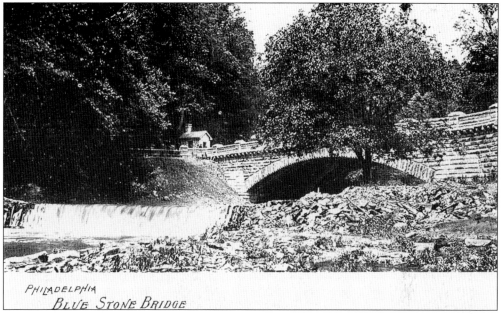

PHILADELPHIA
BLUE STONE BRIDGE

THE BLUE STONE BRIDGE. Below Walnut Lane stands the Blue Stone Bridge, erected between 1896 and 1897. Sometimes it is also referred to as the Lotus Inn Bridge. Interestingly, this is the only bridge to carry the Forbidden Drive over the Wissahickon. Beginning at Lincoln Drive, the Forbidden Drive stretches along the east side of the creek and, at Blue Stone Bridge, crosses over to the west side, where it remains for the length of the park. Prior to this structure, a red covered bridge occupied this spot. (World Postcard Company postcard.)

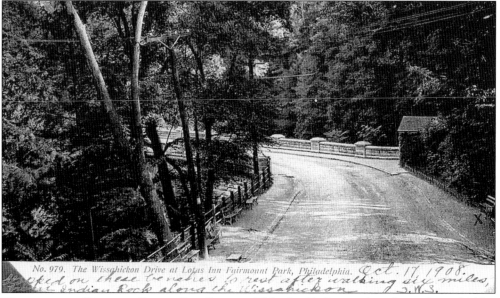

No. 979. The Wissahickon Drive at Lotus Inn Fairmount Park, Philadelphia. Oct. 17, 1908.

WISSAHICKON DRIVE AT LOTUS INN BRIDGE. This nice bird's-eye view shows the Forbidden Drive looking south toward the 1896–1897 Lotus Inn Bridge as it makes a sharp bend over the creek. Interestingly, this image depicts a number of park benches lining both sides of the drive in this area. The message on this postcard states, "Oct. 17, 1908. Stopped on these benches to rest after walking six miles from Indian Rock along the Wissahickon."

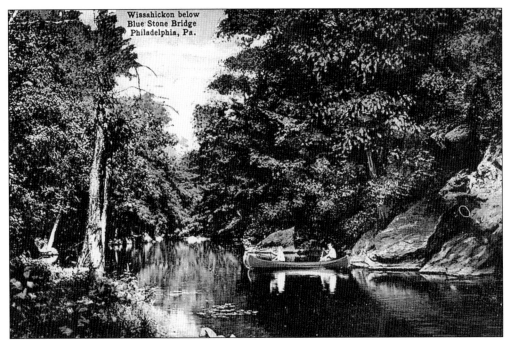

THE WISSAHICKON CREEK BELOW BLUE STONE BRIDGE. A canoe with two young people makes its way along a scenic area of the Wissahickon Creek below the Blue Stone Bridge.

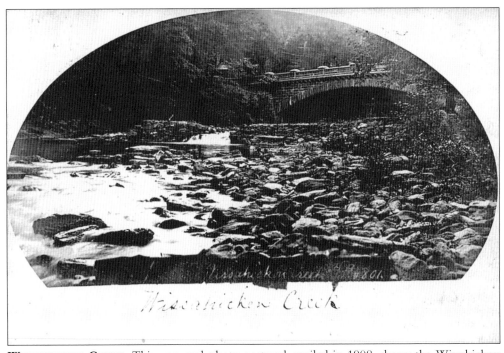

WISSAHICKON CREEK. This rare, real–photo postcard, mailed in 1908, shows the Wissahickon Creek at the Blue Stone Bridge.

Five

ALONG THE CRESHEIM CREEK

ALONG THE CRESHEIM CREEK. Only several miles long, the historic Cresheim Creek begins near Wyndmoor and passes through a series of rapids and waterfalls prior to entering the Wissahickon Creek. The creek's water helped power mills erected by early German settlers in the 1700s. At its junction with the Wissahickon is Devil's Pool, a reportedly favorite Native American gathering place of the past. Today the Cresheim Creek Valley is preserved in Fairmount Park and is illustrated in this chapter.

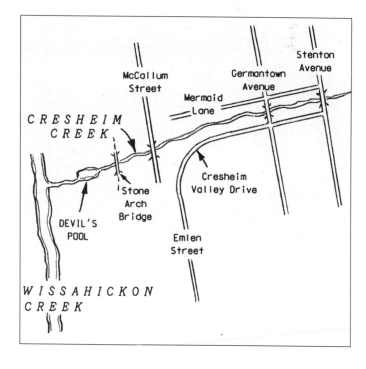

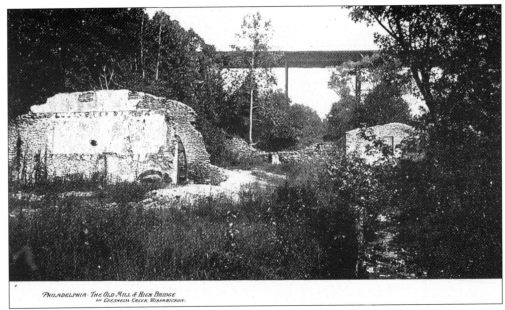

PHILADELPHIA · The Old Mill & High Bridge
on Cresheim Creek, Wissahickon.

THE OLD MILL AND HIGH BRIDGE, CRESHEIM CREEK. Early German Settlers brought skills and customs to this country from their homeland. In many instances, they named places after the regions they were from in Germany. Cresheim is one such name, derived from Kresheim, or Kriesgheim, in the Palatinate region of Germany. Cresheim Creek has its origin near Wyndmoor, Springfield Township, Montgomery County, and flows easterly, emptying into the Wissahickon at Devil's Pool. Shown above are mill ruins along the Cresheim Creek. John Gorgas built an original mill in the 1700s. From 1808 to 1853, it was owned by the George Patterson family and, thereafter until 1879, was owned by Joseph Hill. The High Bridge in the background is the 1890 McCallum Street Bridge, which has been replaced in recent years. The Philip Moore postcard below shows an old wooden waterwheel left over from the old milling days, set inside old stone ruins.

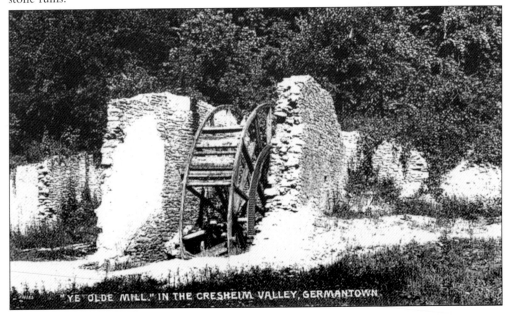

"YE OLDE MILL." IN THE CRESHEIM VALLEY, GERMANTOWN

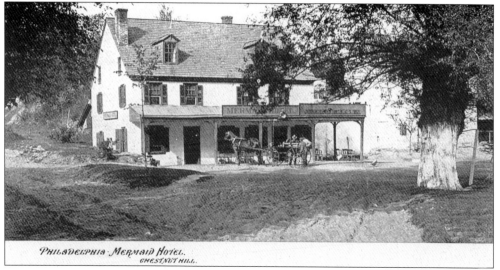

PHILADELPHIA · MERMAID HOTEL.
CHESTNUT HILL.

THE MERMAID HOTEL. A likely spot for a wayside tavern would be where the Cresheim Creek meets Germantown Avenue—the location of the Mermaid Hotel. The Cresheim Creek had been the source of early mills, and the Germantown Road was one of the oldest highways in the area. The Colonial inn dates back to the late 1700s and, as this 1905 view depicts on the wooden sign on the building, was owned by Jacob Hess. Notice the dirt paths and whitewashed tree trunks typical of this period. The Mermaid remained until 1913, when it was demolished. (World Postcard Company postcard.)

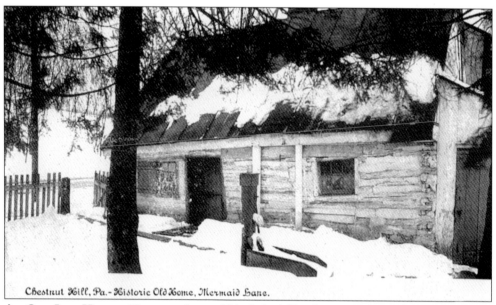

Chestnut Hill, Pa.- Historic Old Home, Mermaid Lane.

AN OLD LOG HOUSE, MERMAID LANE. This Colonial log house was located on Germantown Avenue at Mermaid Lane, near the junction of the Cresheim Creek. This relic from the earliest settlement of the area shows typical log house architecture. German architectural influences are evident in the small, one-and-a-half-story building with square windows and centrally located fireplace. These features are consistent with those of the early German landowners. The house was built *c.* 1743 and was demolished in 1909. (World Postcard Company postcard.)

THE BUTTERCUP INN. There appears to be some question as to the origin of this structure. A 1955 Germantown architectural survey lists its origins as a Colonial 1700s building, erected as a farmhouse. This 1905 view labels it as an inn. In the early 1900s, it was a summer retreat for girls. The 1955 survey lists it at 7400 Emlen Street, near the present Cresheim Valley Drive west of Allens Lane near the Cresheim Creek. The building was demolished in 1958. (World Postcard Company postcard.)

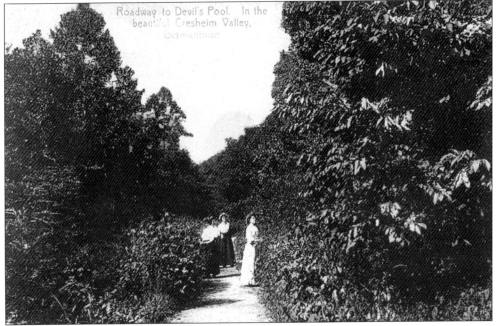

A ROADWAY TO DEVIL'S POOL, CRESHEIM VALLEY. This *c.* 1910 postcard by Philip H. Moore shows a dirt path leading to Devil's Pool. The young ladies appear to be admiring trees and flowers along the path.

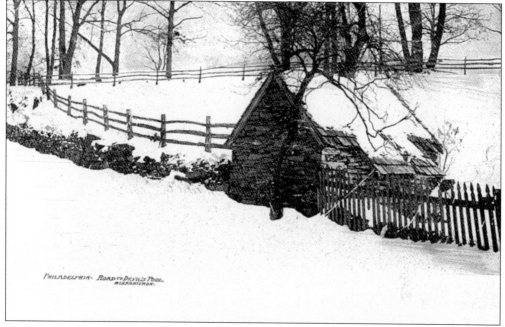

A ROAD TO DEVIL'S POOL. Beautiful rustic scenery was not limited to the Wissahickon Creek; it was apparent in the surrounding area as well. Illustrated in this 1905 postcard is a winter scene of a road leading to Devil's Pool. The scenery depicts a snow-covered landscape with an old stone structure, wooden fences, and trees. (World Postcard Company postcard.)

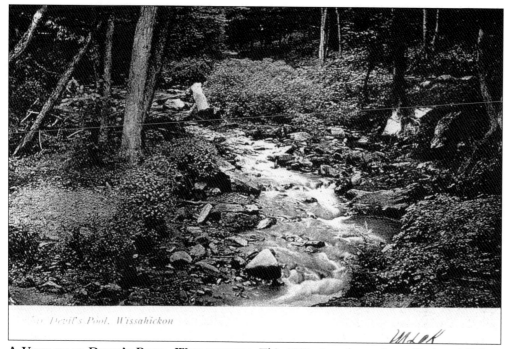

A VIEW NEAR DEVIL'S POOL, WISSAHICKON. This 1905 view shows the swift, downhill flow of the Cresheim Creek as it heads toward the Wissahickon at Devil's Pool.

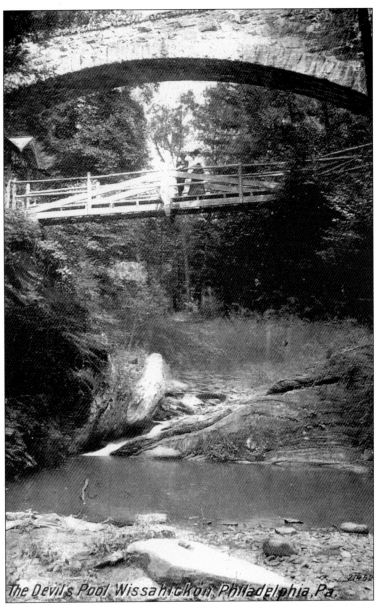

The Devil's Pool Wissahickon Philadelphia, Pa.

THE DEVIL'S POOL. Prior to entering the Wissahickon Creek, Cresheim Creek passes through a series of waterfalls that culminate into a natural pool, surrounded on all sides by massive rocks and boulders. This pool has been known for centuries as Devil's Pool. Many tales have been told through the years as to why the name of Devil's Pool, or Devil's Hole, was given to this place. One legend states that Native Americans drowned in the deceivingly deep water of the pool. In another tale, the pool and waterfall area contain such beauty that the site is a sacred place of worship for Native Americans where good and evil spirits wrestle. Whatever the truth may be, the name of Devil's Pool still survives today, and the place contains some of the most wildly beautiful and rugged landscapes in the park. Along with stately large trees and the collection of massive rocks, Devil's Pool remains a place for artist, poets, and lovers of nature to enjoy within the city of Philadelphia. This postcard shows the stone arch bridge spanning the pool. The stone bridge still stands today, but the wooded footbridge no longer exists.

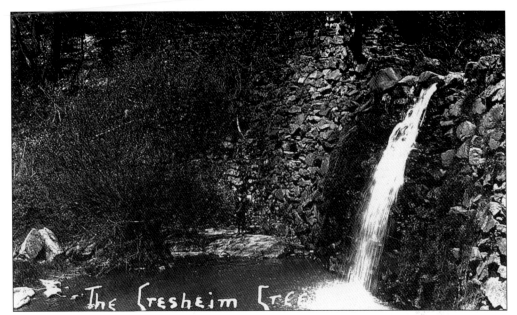

The text on the image reads: The Cresheim Cree

THE CRESHEIM CREEK. Compared to the Wissahickon, Cresheim Creek is much smaller, but its beauty rivals that of the larger stream. This real-photo postcard made by Philip Moore shows a rather large waterfall on the Cresheim Creek. Compare the size of the falls to the young man faintly visible on a rock below. Some of the falls along the Cresheim Creek are natural, while others consist of man-made milldams.

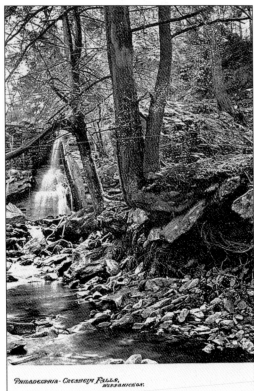

PHILADELPHIA - CRESHEIM FALLS, WISSAHICKON.

CRESHEIM FALLS, NEAR DEVIL'S POOL. Shown in this 1906 view is a glimpse of the falls on Cresheim Creek with some interesting old trees. (World Postcard Company postcard.)

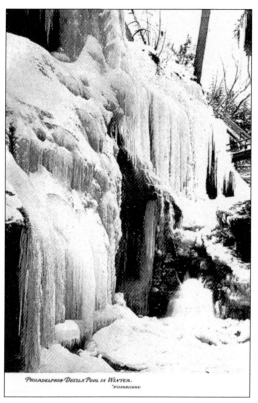

DEVIL'S POOL, CRESHEIM FALLS IN WINTER. Beautiful frozen waterfalls set among large rocks and boulders are shown in these images from 1906. Winter scenes with snow and ice reveal some of the loveliest views along the Wissahickon. (World Postcard Company postcard.)

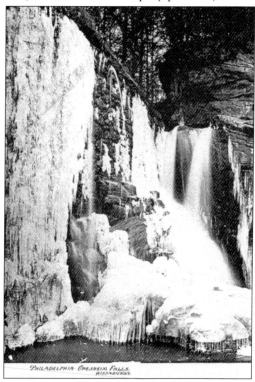

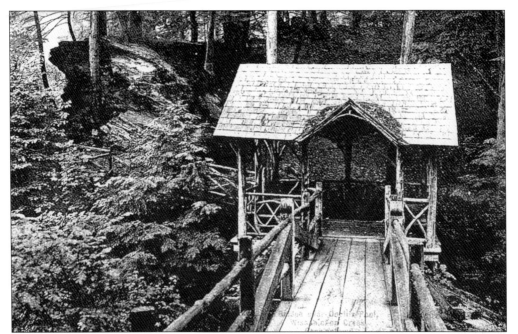

THE BRIDGE OVER DEVIL'S POOL. In the late 1800s, Devil's Pool was a popular site in the park. Rustic wooden bridges, walkways, and a shelter were installed above the falls, offering splendid views of the Cresheim Creek and surrounding landscape. Unfortunately, these structures no longer exist. (Moore postcard.)

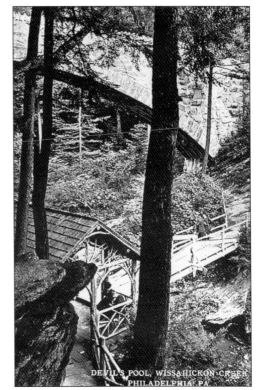

DEVIL'S POOL. From a different vantage point, this view shows the stone pipe bridge, wooden pedestrian bridge, and shelter. To the lower right, a bit of Devil's Pool in a setting of beautiful trees and large rocks may be seen.

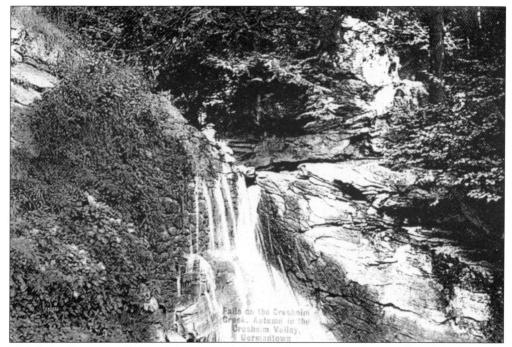

FALLS ON CRESHEIM CREEK. This postcard shows a closeup of Cresheim Falls and the beautiful rock formations. The Cresheim Creek area was a popular place for postcard views. Many images exist by various publishers, showing this unique location. (Moore postcard.)

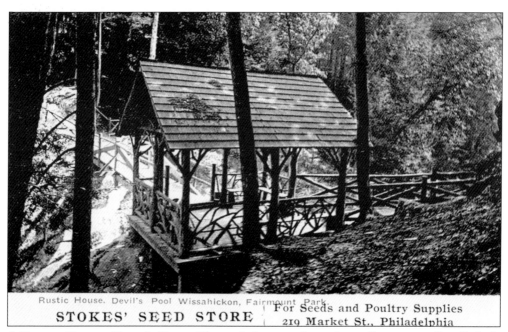

A RUSTIC HOUSE, DEVIL'S POOL. The rustic house and wooden walkways were literally built on top of many boulders and rocks over Devil's Pool. This 1906 postcard also advertises seeds and poultry supplies for a Philadelphia feed store.

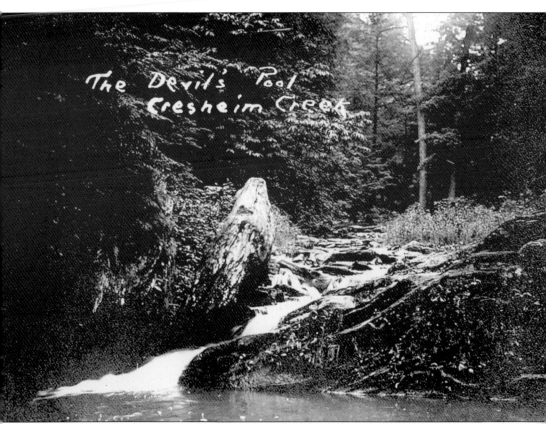

DEVIL'S POOL, CRESHEIM CREEK. Cresheim Creek makes its final falls before emptying into Devil's Pool amid beautiful rocks shown in this 1912 view. (Moore postcard.)

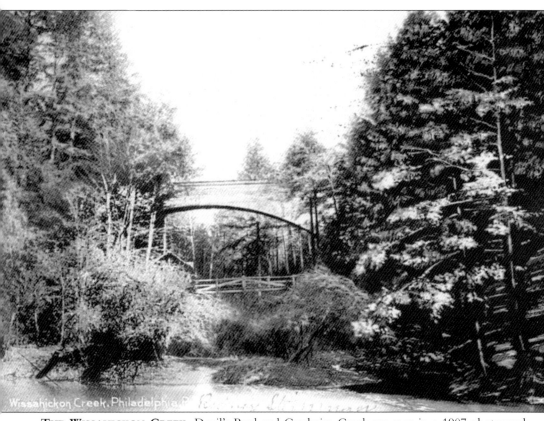

Wissahickon Creek, Philadelphia

THE WISSAHICKON CREEK. Devil's Pool and Cresheim Creek are seen in a 1907 photograph taken from the Forbidden Drive, looking across the Wissahickon Creek. Several bridges have been built spanning the Cresheim Creek as it enters the Wissahickon. The large stone arch bridge carries a city pipeline over Devil's Pool. (Rotograph postcard.)

Six
ALONG LINCOLN DRIVE

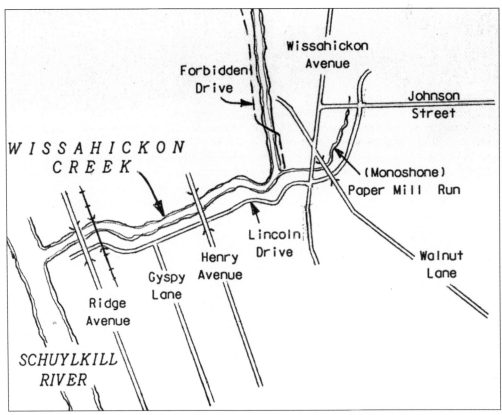

ALONG LINCOLN DRIVE. This chapter follows the last journey of the Wissahickon Creek as it makes its final bend at Lincoln Drive, down toward the Schuylkill River. The steep rocky hills continue along the creek until the last falls, where the Wissahickon joins the Schuylkill. Also highlighted here is Paper Mill or Monoshone Run—a small yet very important and historic tributary to the Wissahickon Creek.

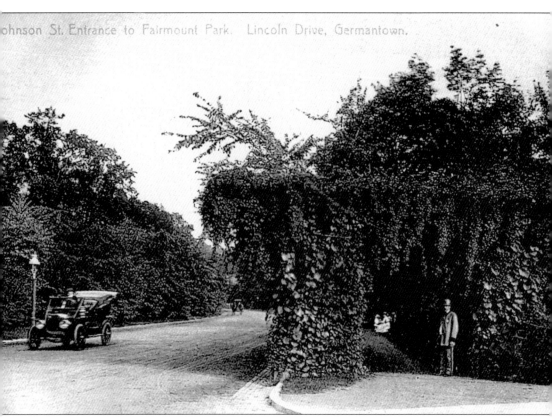

THE JOHNSON STREET ENTRANCE TO FAIRMOUNT PARK. Traveling south on Lincoln Drive at the intersection of Johnson Street, one comes to the entrance to the Wissahickon section of Fairmount Park. This view from 1908 shows an early vehicle traveling on the drive alongside a few pedestrians. Though this area still represents the entrance to the park, the scene is somewhat changed today. The covered walkway to the right no longer exists, and some of the dense woodlands have been trimmed back. (Moore postcard.)

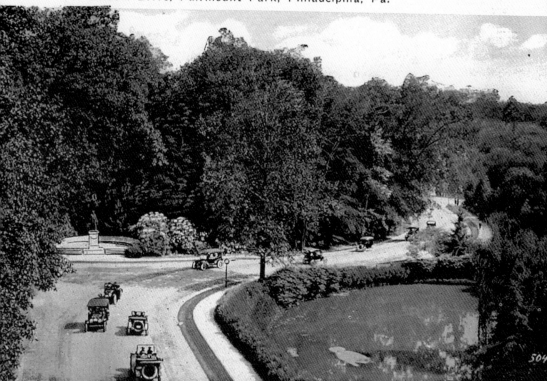

LINCOLN DRIVE, FAIRMOUNT PARK. This 1915 scene shows a busy Lincoln Drive from atop the Walnut Lane overpass, looking south toward Harvey Street. The body of water shown to the right was a small pond formed by a dammed Paper Mill (Monoshone) Run. In the early days of automobiles, the park drives were popular destinations for driving and touring. (P. Sander postcard, Philadelphia, Pennsylvania.)

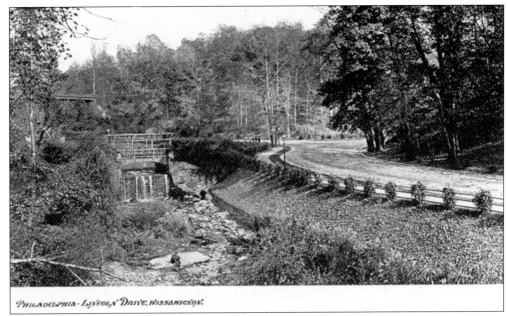

LINCOLN DRIVE. From 1906, this scene shows Lincoln Drive winding north toward Harvey Street. The image is identified as the "Wissahickon," although the stream shown here is Paper Mill (Monoshone) Run, which parallels Lincoln Drive north of the Forbidden Drive. The old Walnut Lane Bridge over Lincoln Drive can be seen in the far distance to the left. (World Postcard Company postcard.)

THE ALDEN PARK APARTMENTS. In Germantown at Wissahickon Avenue east of Lincoln Drive stand the Alden Park Apartments, overlooking the Wissahickon Valley. Built as luxurious apartments in the 1920s, many units contain fireplaces and separate servant entrances. Adjoining part of Fairmount Park, the complex includes three separate high-rise buildings set in a parklike atmosphere. Between 1985 and 1986, the author lived in the Manor building, shown to the right. The wooded area in the background is Wissahickon Park.

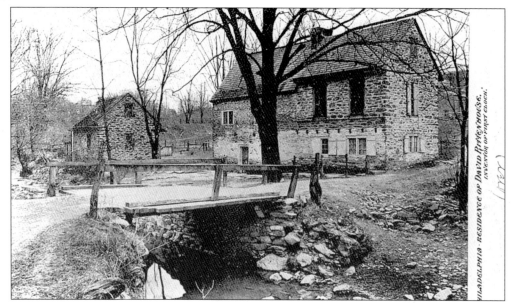

THE RESIDENCE OF DAVID RITTENHOUSE. A complex of Colonial buildings along Monoshone (Paper Mill) Run marks the site of one of the earliest paper mills in America. This area became known as RittenhouseTown, named after 17th-century German immigrant William Rittenhouse, who constructed a mill here in 1690. His small stone cabin, built in 1690, is shown to the left of this 1905 view and is still standing along Lincoln Drive. The house to the right is of equal historical importance, in that it was the birthplace of David Rittenhouse. Several buildings in RittenhouseTown are open for tours in this unique area of Philadelphia. (World Postcard Company postcard.)

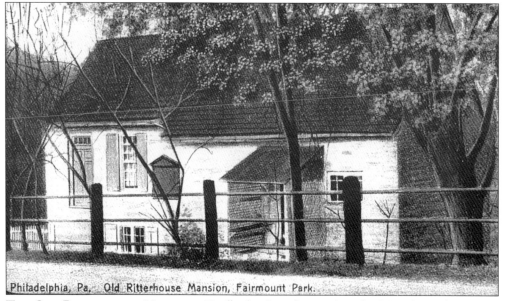

Philadelphia, Pa. Old Ritterhouse Mansion, Fairmount Park.

THE OLD RITTENHOUSE MANSION. Hardly the size of a mansion, the Rittenhouse homestead (built in 1707) measures only 44 feet wide by 18 feet deep. Noted Colonial astronomer and clockmaker David Rittenhouse was born here. This view shows the eastern facade of the house from Lincoln Drive.

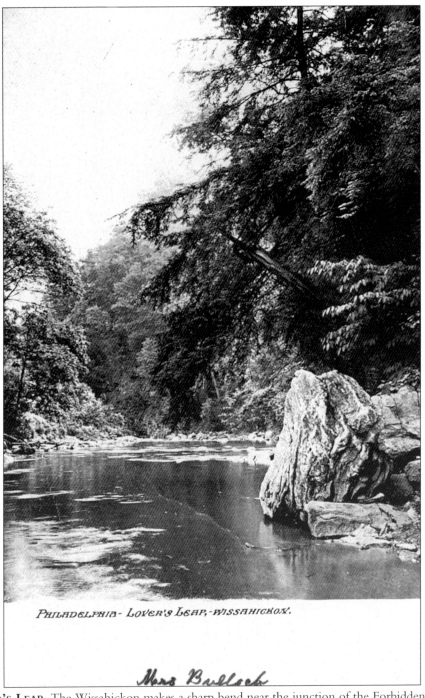

PHILADELPHIA- LOVER'S LEAP,-WISSAHICKON.

Mrs Bullock

LOVER'S LEAP. The Wissahickon makes a sharp bend near the junction of the Forbidden Drive and Lincoln Drive. At this bend, large rocky cliffs rise above the valley. On one of these rocky ledges is the site of Lover's Leap. Tradition states that a young Native American couple jumped to their death in a tribal dispute over their marriage rites. Though not visible in this 1905 view looking south toward Ridge Avenue, Lover's Leap rock is located high above the creek to the right. (World Postcard Company postcard.)

Wissahickon Creek, Fairmount ... delphia, Pa

THE WISSAHICKON CREEK. This 1906 view is looking north along the Wissahickon near Lover's Leap, paralleling Lincoln Drive. In the distance is a large stone bridge with a small arch opening. This bridge carries the Forbidden Drive over Paper Mill Run as that stream empties into the Wissahickon. The *c.* 1800s bridge is still in use. (Rotograph postcard.)

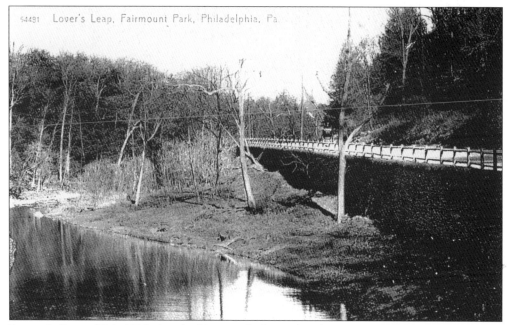

54481 Lover's Leap, Fairmount Park, Philadelphia, Pa.

LOVER'S LEAP. This 1905 view looking north shows the Wissahickon Creek from the area of Lover's Leap. The elevated Lincoln (Wissahickon) Drive is shown to the right as it makes its way toward RittenhouseTown. (Rotograph postcard.)

THE HERMIT LANE BRIDGE. This view from 1910 looks north along Lincoln Drive, and the Hermit Lane Bridge is shown spanning the Wissahickon Creek. The curious name of the bridge is said to come from the hermit of the Wissahickon: German-born John (Johannes) Kelpius, who settled the area in the 1690s. He occupied a cave along a path up the hill from this bridge. He and his followers were very religious. They founded the Tabernacle of the Mystic Brotherhood, in which they believed they would not die and decay but would be transformed into the spiritual world. Hermit Lane Bridge still stands today and was originally opened in the 1790s.

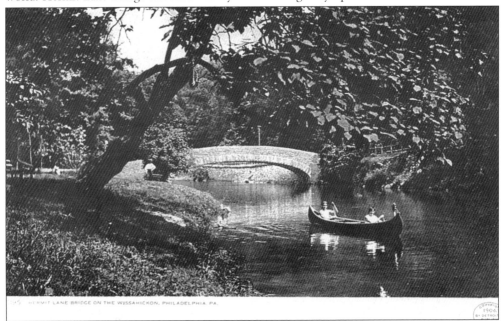

THE HERMIT LANE BRIDGE ON THE WISSAHICKON. Two people are shown canoeing along the Wissahickon Creek near the Hermit Lane Bridge on a sunlit summer day in 1905. (Detroit Publishing Company postcard.)

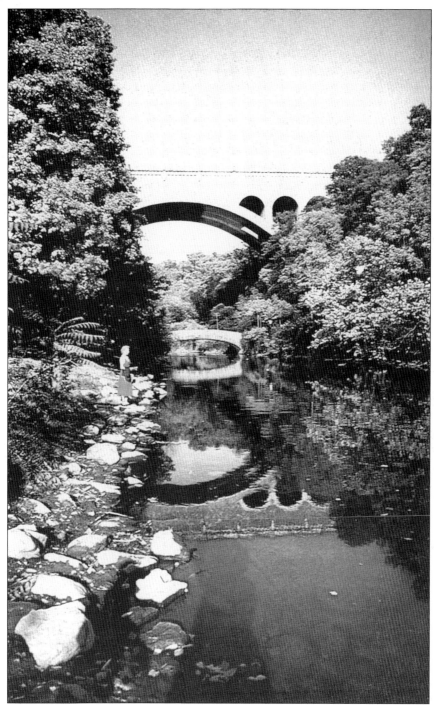

WISSAHICKON BRIDGES. This mid–1950s view looks north along the Wissahickon Creek. Shown here are two bridges representing different centuries and revealing different means of spanning the creek. The mammoth Henry Avenue Bridge, built in the 1920s, spans not only the creek but also the entire valley. The Hermit Lane Bridge, built much earlier, rises only a few feet from the creek.

View of the Wissahickon, Fairmount Park,
Philadelphia, Pa.

A VIEW OF THE WISSAHICKON. This wide-angle doubled-sized view of the Wissahickon looks north toward the Hermit Lane Bridge. Lincoln (Wissahickon) Drive is shown to the right, while the footpath along the creek is to the left. This is a nice view of what the lower Wissahickon

Creek area was like *c.* 1906. Today, the scenery remains the same, but traffic and noise from Lincoln Drive are quite evident. (Rotograph postcard.)

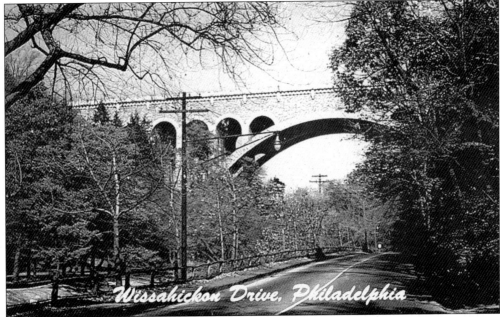

THE HENRY AVENUE BRIDGE. A relatively late addition to the Lower Wissahickon Valley is this picturesque span erected in 1927. Designed by Philadelphia architect Paul Cret, its large, graceful single arch is eloquently accented by smaller arches set inside the bridge. The top view, from *c.* 1955, shows an empty Lincoln (Wissahickon) Drive with a single line in the middle of the road. The view below, from 1960, was taken from the same location and shows some changes to the scene. The utility poles and street lamps have been relocated to the opposite side of the road away from the creek, and a new fence has been installed. Note that a double yellow line is now in the center of the road. Today, this narrow, winding, four-lane drive is heavily used with Cret's bridge dominating the scenic valley and creek.

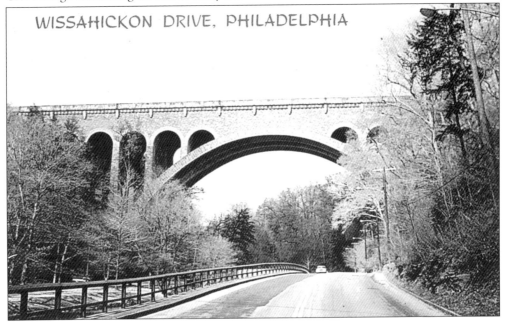

SPRINGS MEMORIAL FOUNTAIN. Motorists traveling along Lincoln Drive below the Henry Avenue Bridge may barely notice a long stone wall accented by a pillared marble center, resembling a Greek Revival doorway. This curiosity was at one time a public drinking fountain. On both ends of the marble facade were fountains for people, and a large central trough was used by horses, as shown in this view. Dating back to the 1800s and seen here in a 1907 view, the fountain bears the name of William Leonidas. Many natural springs are found along the Wissahickon. All the fountains have long been sealed and closed due to pollution. (Taylor Art Company postcard.)

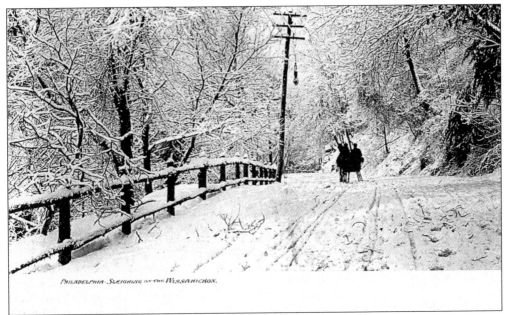

SLEIGHING ON THE WISSAHICKON. "Riding," or "driving," with horses has been a longstanding tradition on the many paths of the Wissahickon. Horses were often clad with sashes of bells that chimed with each trot, making for a most enchanting ride. The view above shows a pristine winter scene, complete with a fresh snowfall as a horse-drawn sleigh makes its way along the Forbidden Drive. The image below shows a busier scene along the drive near Gypsy Lane. (World Postcard Company postcard.)

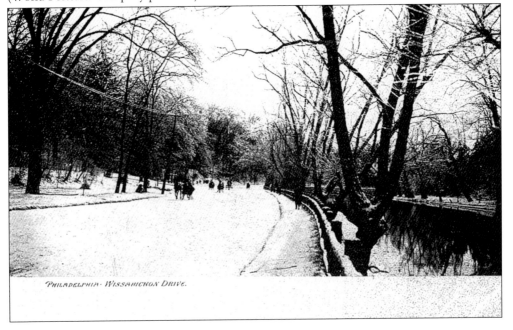

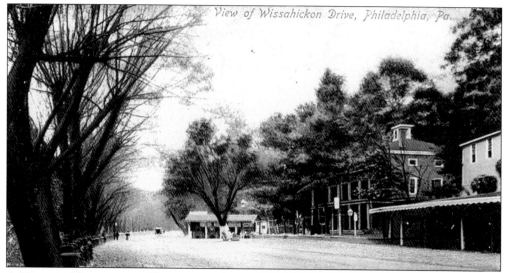

A VIEW OF WISSAHICKON DRIVE. Wissahickon Drive is shown in a view looking north toward Gypsy Lane *c.* 1908. The Wissahickon Creek is to the left of the trees and fence. To the right stands Wissahickon Hall, an early inn built by Harry Lippen in 1849. Wissahickon Hall is still standing today and for decades housed the Fairmount Park Guarded Police. The carriage house to the south of the inn and the horse sheds to the north are gone. At one time, the inn had steps leading down from the drive to the creek and a boat landing. This area of the lower Wissahickon had several hotels and was quite popular for recreation throughout the 1800s to the early 1900s. The Maple Spring Hotel and Log Cabin Inn were situated north of this spot but are no longer standing. (Illustrated postcard, New York.)

WISSAHICKON CREEK AND DRIVE. The beautifully winding Wissahickon Creek and Drive are shown in this scene from 1905, looking north toward Gypsy Lane. (Detroit Publishing Company postcard.)

Wissahickon Drive. Wissahickon (Lincoln) Drive and the creek are shown here *c.* 1900. A lone horse-drawn carriage prods its way along the dirt path of the drive near the vicinity of Gypsy Lane. (World Postcard Company postcard.)

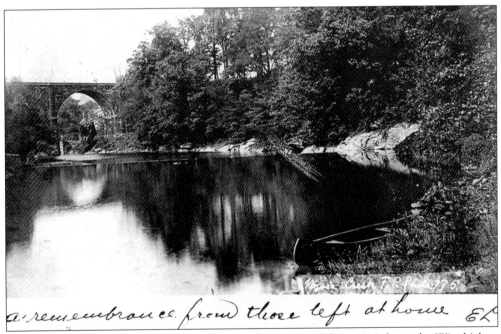

The Wissahickon Creek. This beautiful real-photo postcard from 1910 shows the Wissahickon Creek above the dam, looking south toward the old Reading Railroad bridge at Ridge Avenue. An idle canoe awaits a boater for a pleasant excursion. (Mercantile Studio postcard.)

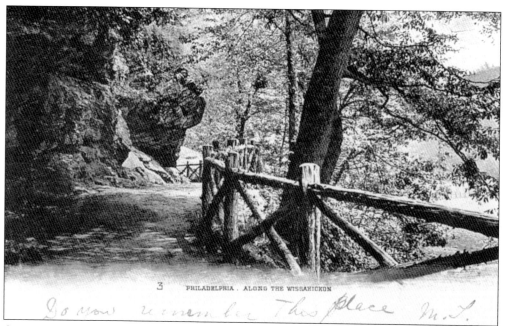

3　　PHILADELPHIA . ALONG THE WISSAHICKON

Do you remember This place M. J.

ALONG THE WISSAHICKON. This 1905 view shows a bit of the trail along the Wissahickon Creek above Ridge Avenue. An old rustic wooden fence follows this narrow path near a rocky area. (World Postcard Company postcard.)

PHILADELPHIA - ENTRANCE TO THE WISSAHICKON.

ENTRANCE TO THE WISSAHICKON. Shown in this 1906 view is the entrance to the Wissahickon from north of Ridge Avenue. The narrow path along the creek from Ridge Avenue to the Forbidden Drive is sometimes overlooked but contains some very beautiful scenery. (World Postcard Company postcard.)

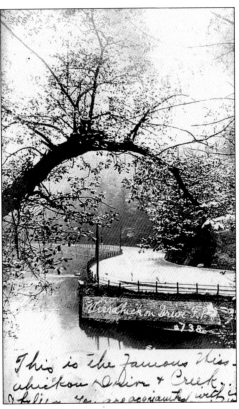

WISSAHICKON CREEK AND DRIVE. The Wissahickon Creek meanders and curves its way from Central Montgomery County, down into Philadelphia. In this 1907 view, the creek makes one last bend above Ridge Avenue before entering the Schuylkill River. Lincoln (Wissahickon) Drive is shown winding along the side of the creek. This scene is relatively unchanged today, with the exception of the many vehicles that travel on Lincoln Drive. (Mercantile Studio postcard.)

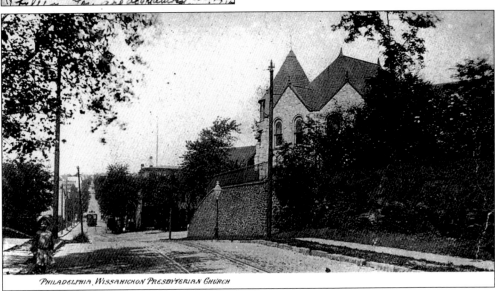

WISSAHICKON, PHILADELPHIA. A small section of the city near Roxborough takes its name from the Wissahickon Creek. The Wissahickon section of the city is situated on a hill west of the creek, along Ridge Avenue. The Wissahickon neighborhood is relatively small but does contain the Wissahickon train station as well as numerous churches and, at one time, a public library. This 1905 view, looking west on Manayunk Avenue toward Ridge Avenue, shows the Wissahickon Presbyterian Church. (World Postcard Company postcard.)

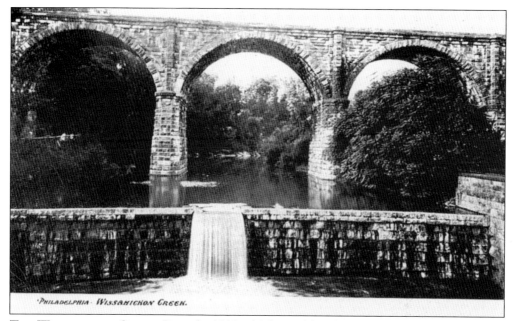

'PHILADELPHIA · WISSAHICKON CREEK.

THE WISSAHICKON CREEK. Since the 1800s, this beautiful multi-arched stone bridge has graced the entrance of the Wissahickon Creek, Wissahickon Drive, and Wissahickon Park. Located immediately above Ridge Avenue, the bridge carried the Philadelphia and Reading Railroad over the Wissahickon. (World Postcard Company postcard.)

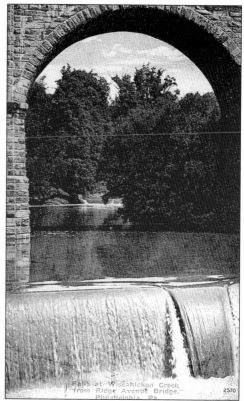

Falls at Wissahickon Creek from Ridge Avenue Bridge, Philadelphia, Pa. 2370

THE FALLS AT THE WISSAHICKON CREEK FROM RIDGE AVENUE BRIDGE. The beautiful Wissahickon is framed by one of the arches from the old Reading Railroad bridge. The bridge and falls can still be seen today.

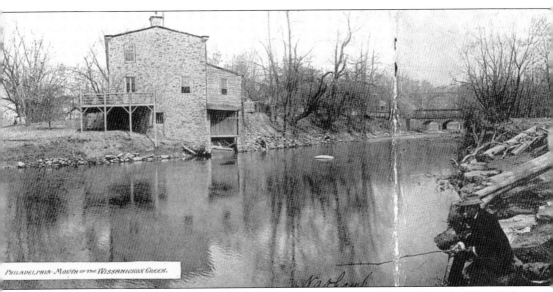

PHILADELPHIA - MOUTH OF THE WISSAHICKON CREEK.

THE MOUTH OF THE WISSAHICKON. A well-dressed man is seen fishing along the Wissahickon where it meets the Schuylkill River. Shown upstream are the Ridge Avenue and Reading Railroad bridges. It is at this site that the Wissahickon ends its 21-mile journey and empties into the Schuylkill River. The building shown to left houses the Philadelphia Canoe Club. (World Postcard Company postcard.)

Seven

SCENERY IN
WISSAHICKON PARK

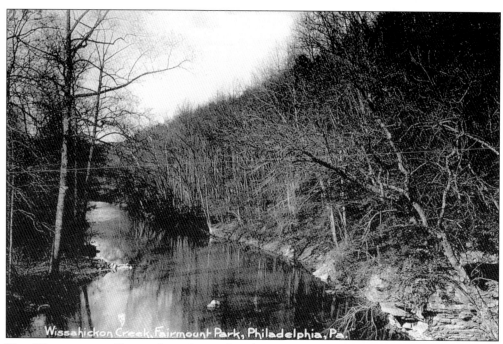

THE WISSAHICKON CREEK. Sometimes referred to as a miniature gorge, the Wissahickon Creek winds its way through a deep valley of rocky hills covered with trees in Fairmount Park. Some hills overlooking the creek rise 200 feet, offering splendid views of the area. For generations, Philadelphians have enjoyed the wonders of the Wissahickon Valley. This view dates from 1908. (Rotograph postcard.)

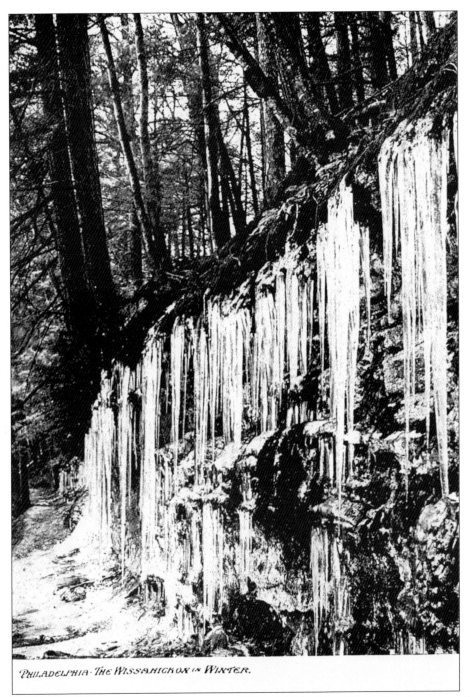

PHILADELPHIA - THE WISSAHICKON IN WINTER.

THE WISSAHICKON IN WINTER. Steep, rocky cliffs and high-rising hills define the deep valley of the Wissahickon Creek in Fairmount Park. Some of these north-facing rocky cliffs seldom see any sunlight, especially in winter. Trickling water that flows from underground springs near rocks often freezes in the colder months and creates a variety of interesting icicles, as seen in this view. The ever-changing weather offers park visitors an array of wondrous natural attractions. This postcard dates from 1905. (World Postcard Company postcard.)

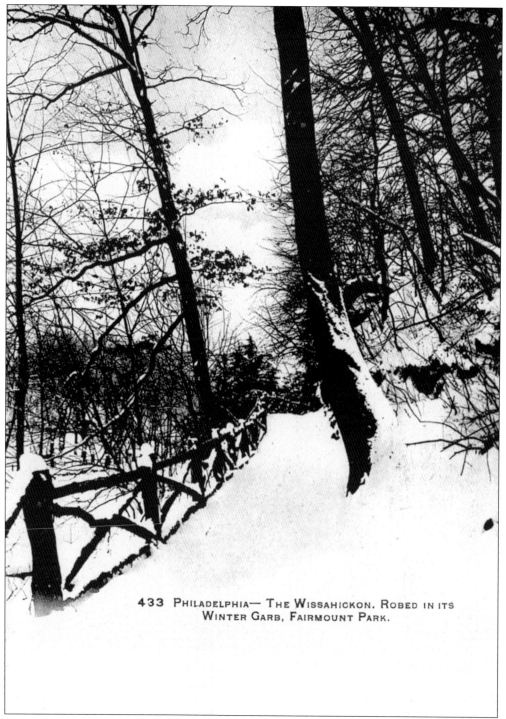

433 PHILADELPHIA— THE WISSAHICKON. ROBED IN ITS
WINTER GARB, FAIRMOUNT PARK.

THE WISSAHICKON ROBED IN ITS WINTER GARB. Few postcards show the Wissahickon in a wintertime snow scene, and yet those are some of the prettiest views one would find of the park. Here, a freshly fallen undisturbed snowfall from *c.* 1905 has blanketed a footpath area. Each season adds a different dimension of beauty to the park.

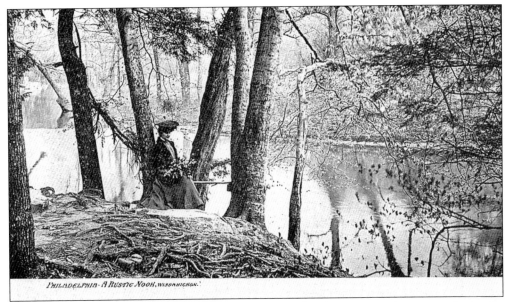

A RUSTIC NOOK, WISSAHICKON. The Wissahickon has long attracted many to its banks. Beautiful scenery pleases the eye in every direction. In this 1905 view, a young, well-dressed Philadelphian has found a perfect nook between two trees to enjoy the cooling waters of the Wissahickon. (World Postcard Company postcard.)

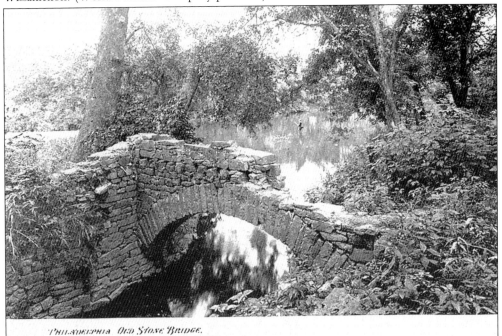

AN OLD STONE BRIDGE. In 1905, the remnants of an old stone bridge caught the eye of a photographer along the banks of the Wissahickon. The location appears to be near a small tributary entering the creek. The author has been unable to identify this exact location. Images such as this preserve old scenes along the Wissahickon that no longer exist. (World Postcard Company postcard.)

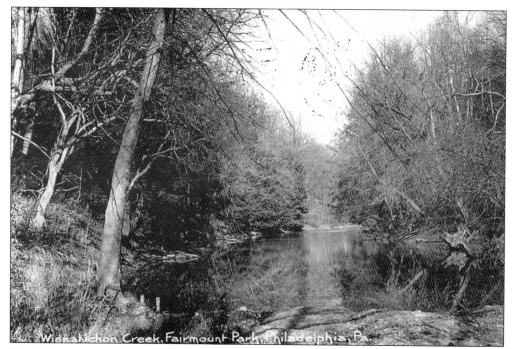

THE WISSAHICKON CREEK. In this 1905 postcard, bright sunlight enriches the beautiful scenery of the creek in Fairmount Park, Philadelphia, on a quiet winter day. For city folks, the tranquil creek evokes a sense of calm and serenity in the park. (Rotograph postcard.)

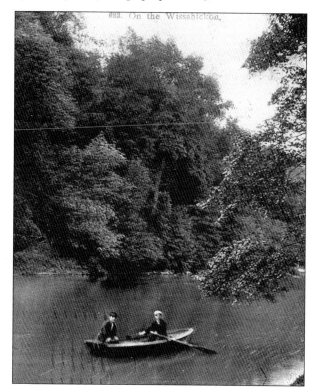

ON THE WISSAHICKON. In this 1908 image, a pleasurable outing is in store for two young boys as they canoe on the Wissahickon Creek in Fairmount Park. Canoeing was once very popular here but is seldom seen today.

ON THE WISSAHICKON. The serene and tranquil Wissahickon Creek is viewed from a bend along the Forbidden Drive in this 1910 scene. The curving and winding creek and paths provide a wide assortment of views. (Bunnell postcard.)

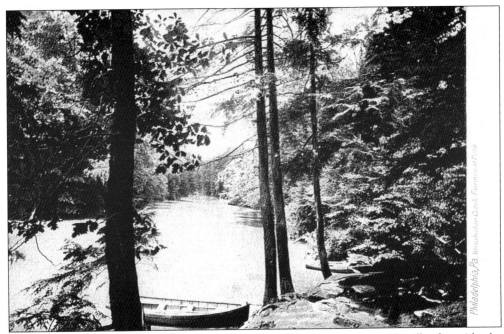

THE WISSAHICKON CREEK. Amid a beautiful wooded forest, a canoe sits idle alongside the Wissahickon in this 1908 scene. (Hugh Leighton postcard, Portland, Maine.)

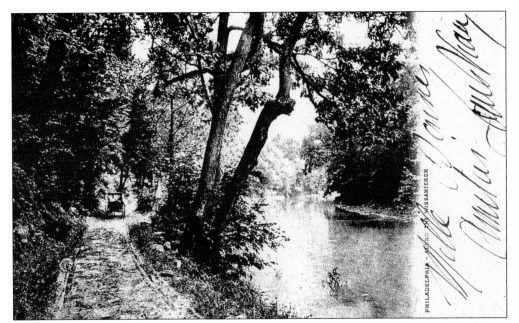

ALONG THE WISSAHICKON. A very early scene along the Wissahickon Creek shows a horse-drawn carriage traveling along a dirt path. This postcard is from 1905, but the photograph used probably dates from the late 1800s. (World Postcard Company postcard.)

ON THE WISSAHICKON. The Wissahickon Creek is viewed through old trees on a winter day *c.* 1900. (World Postcard Company postcard.)

A VIEW ON THE WISSAHICKON CREEK. A different perspective of the Wissahickon is depicted in this 1907 image. Shown are the rocky banks that line the creek throughout Fairmount Park. (Rotograph postcard.)

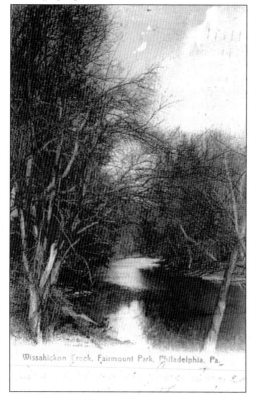

THE WISSAHICKON CREEK, FAIRMOUNT PARK. This beautiful scene of the Wissahickon Creek in Fairmount Park dates from 1905. (Rotograph postcard.)

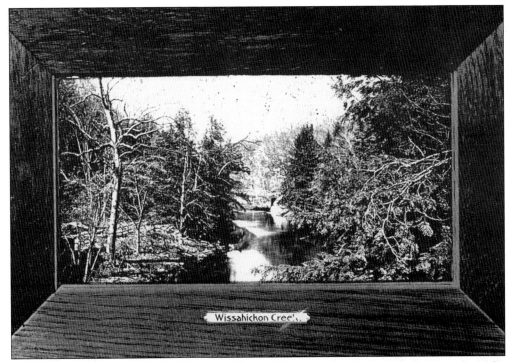

THE WISSAHICKON CREEK. There are many interesting varieties of postcard scenes along the Wissahickon Creek. Styles range in color, black-and-white, photographic, and artistic renderings. One unique series shows Wissahickon scenes inserted in a photographed wooden frame, as seen in this view from 1909, by the Rotograph Company from New York.

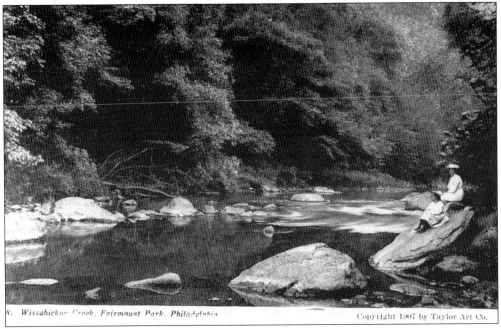

8. *Wissahickon Creek, Fairmount Park, Philadelphia* Copyright 1907 by Taylor Art Co.

ADMIRING THE WISSAHICKON CREEK. A pair of young women admires the beautiful Wissahickon from a large rock in this 1907 view. (Taylor Art Company postcard.)

115

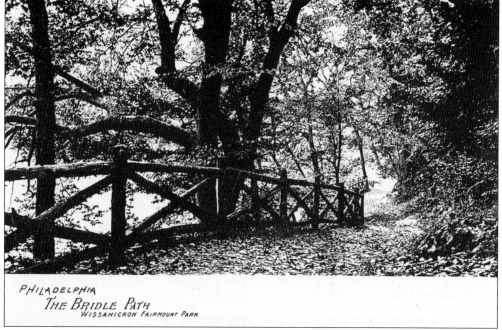

PHILADELPHIA
THE BRIDLE PATH
WISSAHICKON FAIRMOUNT PARK

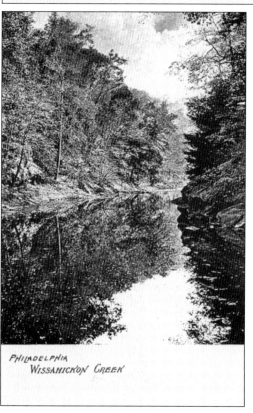

PHILADELPHIA
WISSAHICKON CREEK

THE BRIDLE PATH AND WISSAHICKON CREEK. These views illustrate the natural, rugged wilderness of the Wissahickon Valley. The image above shows an old rustic fence bordering a path along the creek. Fences such as this one may date back to the mid–1800s, when park trails were initially laid out. In the view to the left, beautiful reflections of interesting rocks and old trees are seen in the tranquil, clear Wissahickon. (World Postcard Company postcards.)

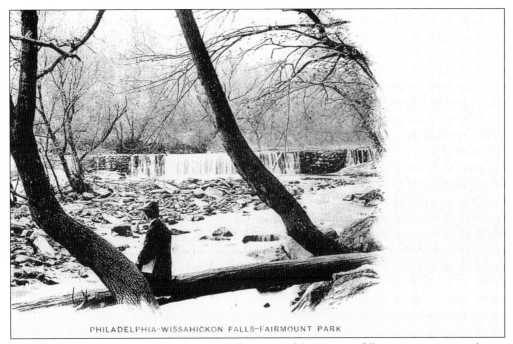

PHILADELPHIA-WISSAHICKON FALLS-FAIRMOUNT PARK

THE WISSAHICKON FALLS. A young man finds a restful spot on a fallen tree to pause and gaze at a pretty spot near one of the falls along the Wissahickon Creek. The postcard dates from 1905.

Philadelphia, Pa. Lower Wissahickon Creek, Fairmount Park.

THE LOWER WISSAHICKON CREEK. A glimpse of the lower Wissahickon Creek is seen through leafy tree branches in this view from 1909. (Bunnell postcard.)

117

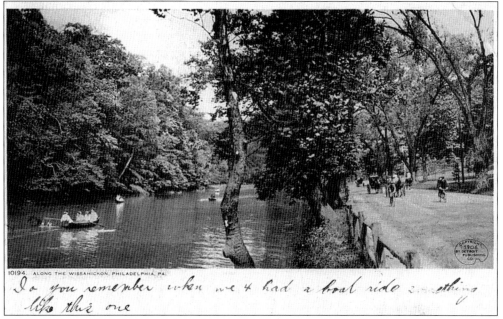

10194. ALONG THE WISSAHICKON, PHILADELPHIA, PA.

Do you remember when we 4 had a boat ride something like this one

ALONG THE WISSAHICKON. This summertime view from *c.* 1905 illustrates park activities along the Wissahickon. The Forbidden Drive is bustling with bicyclists, horse-drawn carriages, and hikers, while those in canoes enjoy the creek. The wonderful, simple pleasures of the great outdoors have been enjoyed along the banks of the Wissahickon for generations. (Detroit Publishing Company postcard.)

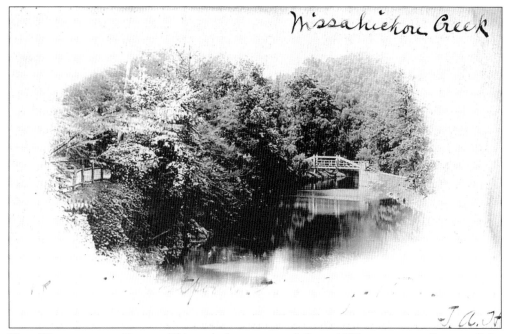

THE WISSAHICKON CREEK. This real-photo postcard from 1905 captures a glimpse of the Wissahickon Creek near an old bridge with the Forbidden Drive shown to the left. This view may be quite unique in that it is not a commercially produced image.

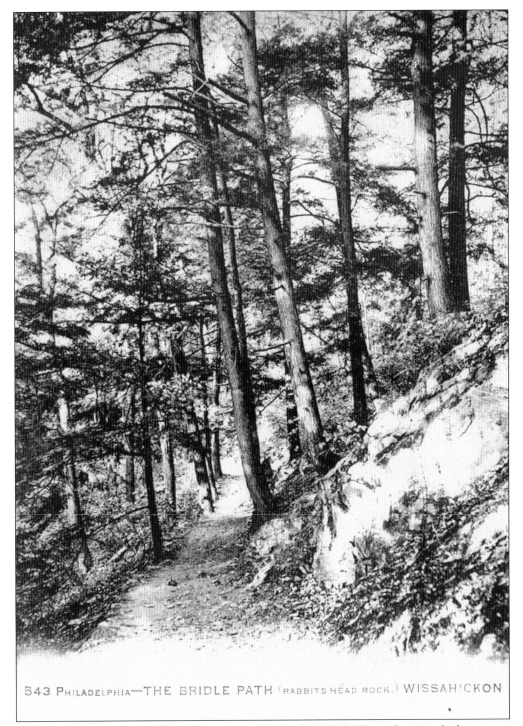

543 PHILADELPHIA—THE BRIDLE PATH (RABBITS HEAD ROCK.) WISSAHICKON

THE BRIDLE PATH, RABBITS HEAD ROCK. One of the paths along the Wissahickon passes Rabbits Head Rock. The naming of the many rocks along the Wissahickon is due to their odd shapes. Here, Rabbits Head Rock probably resembles the head of the rabbit, though it appears to be questionable in this 1905 view.

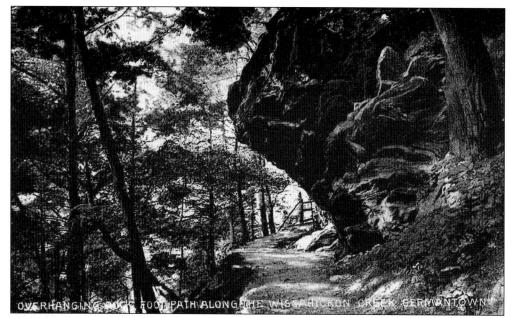

AN OVERHANGING ROCK AND A FOOTPATH ALONG THE WISSAHICKON. Perhaps the most outstanding features of the Wissahickon area are numerous large rock formations. Many rocky areas have been given names, ranging from Pillared Rock, Mom Rinker's Rock, Indian Rock, and as seen here, Overhanging Rock. The rock formations are comprised of two rock types— schist and quartzite. The grayish schist is made up of layers of silt that have been compacted in water, forming clay and hardening into rock over many years. Brownish quartzite is formed by sand that was once moving in water and has compressed into rock. The outstanding collection of rocks greatly enhances the beauty of the Wissahickon. This image dates from 1915. (Moore postcard.)

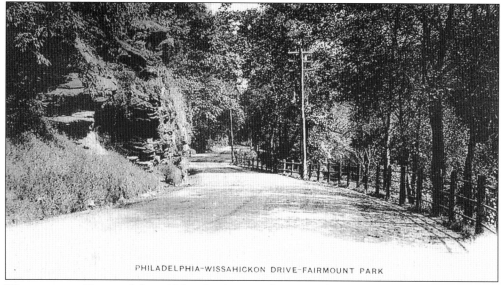

WISSAHICKON DRIVE. A beautiful and quiet area along Wissahickon Drive is seen in this view from 1905. Once again, the area is dominated by thick foliage and large boulders that characterize the lower Wissahickon Valley.

120

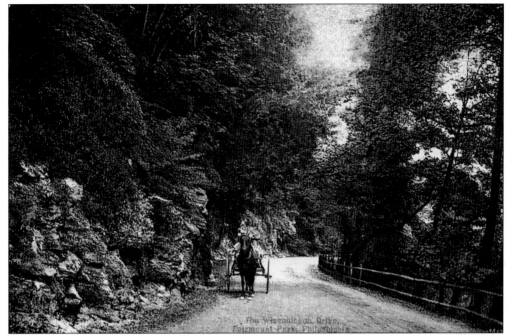

WISSAHICKON DRIVE. Hiking and horseback riding has always been a mainstay along the Wissahickon trails, but horse-drawn open carriages, such as the one pictured here in 1915, are only occasionally seen. (Moore postcard.)

A FOOTPATH ALONG THE WISSAHICKON CREEK. A wooden bench is seen in a hilly area along a footpath amid towering trees. Beautiful scenery abounds the footpath trails along the Wissahickon Creek. This postcard dates from 1915. (Moore postcard.)

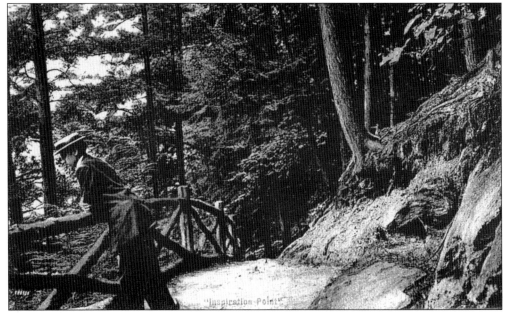

INSPIRATION POINT. This postcard, by Germantown's own Philip Moore, shows a well-dressed young man pausing on a footpath along the Wissahickon. Moore identified this as "Inspiration Point," yet there appears to be no specific information about its exact location. Perhaps Moore used his own words and feelings to identify the image. For those familiar with the Wissahickon, the entire park could be considered inspirational.

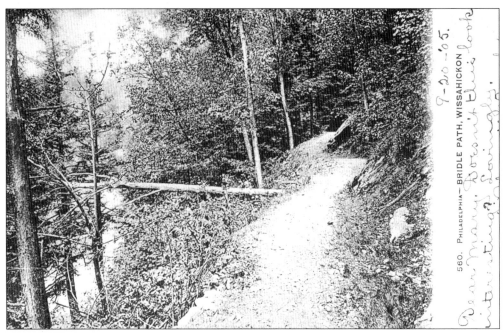

THE BRIDLE PATH. Many of the bridle paths, or footpaths, along the Wissahickon are found on the east side of the creek. Here, hikers traverse steep hills, rocky glens, and beautiful forests along the creek's edge. Rebecca writes to Mary in this 1905 postcard, "Doesn't this look interesting?"

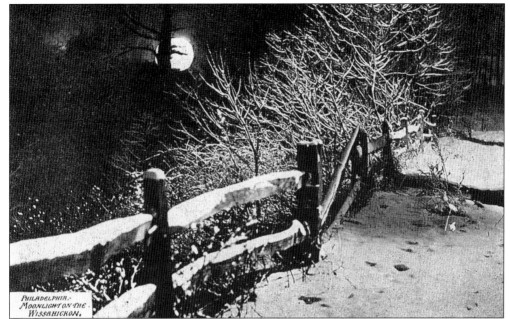

MOONLIGHT ON THE WISSAHICKON. A rather interesting and rare nighttime view of the Wissahickon is captured on a snow-covered Forbidden Drive with a full moon in 1905. Nighttime images on early postcards are very scarce. For those who have ventured into the park at night, the area possesses an eerie feeling, which appears to be illustrated quite well here. (World Postcard Company postcard.)

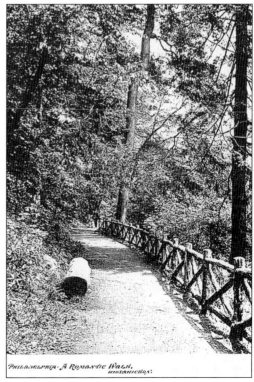

A ROMANTIC WALK, WISSAHICKON. A winding path bordered by an early park fence is shown as a "Romantic Walk" in the Wissahickon Valley. This view dates from 1907. (World Postcard Company postcard.)

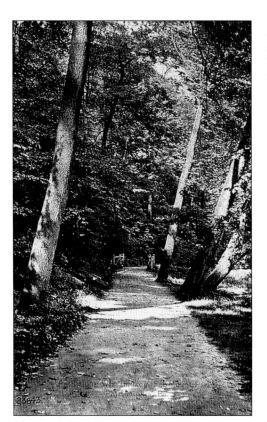

A Path along the Wissahickon.
A scenic view from 1910 shows a typical well-shaded path in Wissahickon Park with sun-dappled trees.

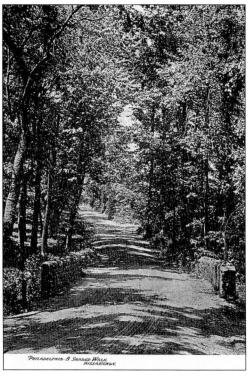

A Shaded Walk, Wissahickon.
This 1905 postcard shows a nicely shaded path (possibly along Forbidden Drive) near the Wissahickon at a small stone bridge. During the warm days of summer, the shade from trees along the Wissahickon provides cool relief for park visitors. (World Postcard Company postcard.)

THE WISSAHICKON NUTCRACKER. This humorous photograph was taken by Philip H. Moore *c.* 1913. Moore, who lived from 1879 to 1958, had a studio at 6646 Germantown Avenue. He photographed many local scenes and produced many postcards; several are found in this book. Adding to the interest of this postcard is that it was actually signed and mailed by Moore in 1913. Many descendants of this "nutcracker" are found in the park today.

A FOOTPATH, WISSAHICKON. This rare, real–photo image dating from *c.* 1905 captures what would appear to be formally dressed Philadelphians walking along a Wissahickon footpath. Actually, this would be the standard attire for folks out for a hike in the park 100 years ago. Even in the hottest weather, heavy clothing was not optional but the standard. This view shows that the Wissahickon has been enjoyed by the public for over a century.

THE BRIDLE PATH, WISSAHICKON. The scenic bridle path along the Wissahickon is shown in a view from 1905. A lone hiker walks beneath a forest canopy of hemlocks and pine trees, most likely on the east side of the creek.

THE BRIDLE PATH. Another 1905 view shows one of the many old bridle paths in the Wissahickon Park. With so many changes in our area over the last century, it is a welcome site to see some places remain unchanged. Throughout the park, the natural landscape continues to endure. (World Postcard Company postcard.)

BIBLIOGRAPHY

Brandt, Francis Burke. *The Wissahickon Valley within the City of Philadelphia.* n.p., 1927.

Carter, Velma Thorne. *Penn's Manor of Springfield.* Wyndmoor, Pennsylvania: the Township of Springfield, Montgomery County, Pennsylvania, 1976.

Daly, T.A. *The Wissahickon.* Philadelphia, Pennsylvania: the George Buchanan Company, 1922.

Eberlein, Harold Donaldson, and Cortlant Van Dyke Hubbard. *Portrait of a Colonial City Philadelphia 1670–1838.* Philadelphia, Pennsylvania: the J. B. Lippincott Company, 1939.

MacFarlane, John F. *History of Early Chestnut Hill.* Philadelphia, Pennsylvania: the City History Society of Philadelphia, 1927.

Ruth, Phil Johnson. *Fairland, Gwynedd.* Souderton, Pennsylvania. Indian Valley Printing, 1991.

Tinkcom, Harry M. and Margaret. *Historic Germantown, A Survey of the German Township.* Philadelphia: the American Philosophical Society, 1955.

White, Theo B. *Farimount: Philadelphia's Park.* Cranbury, New Jersey: Associated University Presses, 1975.

Whitpain Township Bicentennial Commission. *Whitpain, Crossroads in Time.* n.p., 1977.